MW00563882

All photos by the author unless otherwise noted.

Project editor: Meredith Dias
Text design/layout: Casey Shain

Library of Congress Cataloging-in-Publication Data
Hammer, Roger L.
 Florida icons : fifty classic views of the Sunshine State / Roger L.
Hammer.
 p. cm.
 Includes bibliographical references and index.
 ISBN 978-0-7627-7155-4 (alk. paper)
 1. Florida—Description and travel—Miscellanea. 2. Florida—History,
Local—Miscellanea. 3. Florida—Biography—Miscellanea. I. Title.
 F311.6.H36 2011
 975.9—dc23 2011019086

Printed in China

10 9 8 7 6 5 4 3 2 1

Florida ICO

50 CLASSIC VIEWS
OF THE SUNSHINE ST

Roger L. Hammer

gpp®

Guilford, Connecticut

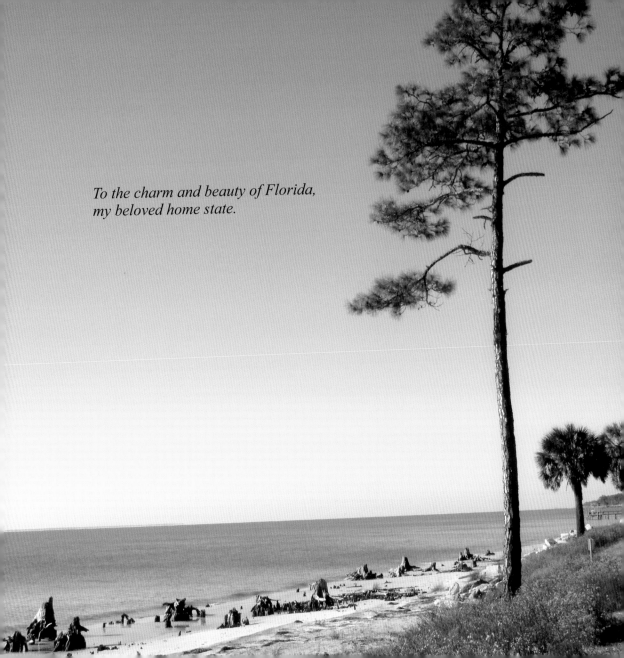

*To the charm and beauty of Florida,
my beloved home state.*

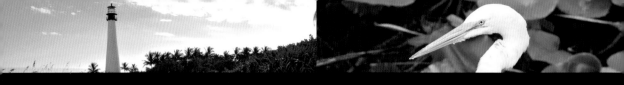

CONTENTS

INTRODUCTION

For the quintessential Florida experience, drive slowly through some of the quiet, sleepy North Florida towns along their winding country roads lined by big oak trees festooned with Spanish-moss. There you can still find remnants of Old Florida, a Florida that is more a state of mind than a place. It is collard greens country, where life moves slow and easy. You will see old rustic and weathered frame homes with rusty tin roofs, clotheslines tied to trees, charming little churches tucked away in the woods beside quiet cemeteries, and old-timers who wave at you from their front porch as they watch their chickens scratch for worms. They may seem poor but their lives are rich beyond words. It won't take long for Old Florida to seep into your soul and make you yearn for the simpler life enjoyed by Florida crackers of old. It is the forgotten Florida, but to those of us who were born here, it is the real Florida.

What image comes to mind when you think of modern-day Florida? Sunshine? Palms? Beaches? Oranges? Disney World? There are those things and so much more to be seen and enjoyed in this state that Juan Ponce de León named *La Florida*. Although Florida is officially called the "Sunshine State," and there certainly is plenty of sunshine here, Florida also receives more rainfall

each year than any other state. Central Florida sustains more lightning strikes than anywhere else in the country, there are more reported shark attacks in Florida each year than in any other region on Earth, and Florida is the most hurricane-prone of all fifty states. Florida also has bragging rights over the second-largest freshwater lake in the United States, 663 miles of beaches, and more than eleven thousand miles of rivers, streams, and waterways. The longest stretch of US Highway 1 is in Florida and, if you drive south on it, you will end up at mile marker 0 in Key West. Indeed, if you want to take a rocket to the moon your journey must begin in Florida.

How do you get the best out of all this? Try swaying to some hip folk blues at the Orange Blossom Jamboree, drifting lazily along on an inner tube down the wonderfully beautiful Ichetucknee River, hiring a fishing guide and stalking 200-pound tarpon on the flats with a fly rod, or taking in the nightlife along Ocean Drive on Miami Beach. Or you could forget about the rest of the world and paddle a canoe for a week or more along the remote and daunting 99-mile Everglades Wilderness Waterway. You might see bald eagles steal fish from ospreys, magnificent frigatebirds soar gracefully overhead, or bottlenose

dolphin ravage schools of fish for dinner. Enjoy some fried catfish at The Yearling restaurant in Cross Creek, slurp a dozen fresh raw oysters at Apalachicola, or check out the world-famous Ron Jon Surf Shop in Cocoa Beach. While there try your hand at surfing or skim boarding. Drive down to the beautiful Florida Keys and go trolling offshore for huge marlin and sailfish during the day, watch for the green flash at sunset with the crowd at Mallory Square in Key West, and then at night sit on a barstool in Capt. Tony's Saloon, where Ernest Hemingway bided away more than his share of time. Maybe Jimmy Buffett will be there. Look for me there, too.

Today's Florida is so diverse, it is difficult to define it. North Florida is a contradiction in terms, being more Southern than the rest of the state. It is the area that Florida journalist Al Burt aptly characterized as the "Tropic of Cracker." After all, Georgia and Alabama border the region, so North Florida is actually a continuation of the Deep South. The Florida Panhandle is the location of the state capital, Tallahassee, along with some of the prettiest hilly countryside found anywhere in the country. Unlike the southern half of Florida, tourist season in the Panhandle is in summer, where Alabamans and Georgians go to enjoy the stunningly beautiful state parks and the powdery white-sand beaches. In fact, the Panhandle beaches are jokingly called the "Redneck Riviera," and the "Forgotten Coast." This is where the esteemed Apalachicola oysters are harvested in the traditional fashion, from a skiff with a rake.

Central Florida is famously synonymous with that sprawling mega-attraction called Walt Disney World that millions of visitors converge upon each year with a desire to delve into a world of fantasy. Central Florida is also the citrus belt, where most of the oranges and grapefruits are grown, and cattle ranches stretch for miles. Even the coasts of Central Florida are different, with long, sandy, high-energy beaches on the east coast that offer a playground for surfers, sunbathers, and swimmers, and where people go to watch astronauts soar into outer space from Cape Canaveral. The west coast is more laid back, with somnolent Gulf towns occasionally interrupted by bustling cities like Tampa, St. Petersburg, and Sarasota. Some of the best fishing in the state is in Central Florida, along with some incredible bird-watching opportunities too, so bring your binoculars and check out the Merritt Island National Wildlife Refuge.

Southeast Florida has metamorphosed into an ethnic melting pot, with people from all parts of

the Caribbean and Latin America calling it home. It is the gateway to the Bahamas and the islands of the Caribbean and a springboard to the tropical Americas. Miami is, in fact, closer to Cuba than to Orlando and nearer to Jamaica than to Georgia. Bimini is just fifty miles from Miami or, to put it in perspective, closer than West Palm Beach. More Spanish is heard spoken in Southeast Florida than in the rest of Florida combined. Creole, too. Southeast Florida is mostly flat, with elevations above sea level ranging from three to twenty feet, so it's a great place for biking and hiking if you like endless stretches of flat land.

Southwest Florida is dominated by 1.5 million acres of swampland called the Everglades, along with the great watery expanse of the adjacent Big Cypress National Preserve. Old gladesmen like to tell unwitting tourists that if they want to carry on a conversation in the Everglades they'll have to throw a rock through the mosquitoes and yell through the hole. During the summer this comes close to being true. Southwest Florida also boasts cities like Naples, which lies in stark contrast to the Everglades by claiming the most golf holes per capita in the United States. If you love swamps, Southwest Florida is also home to the fabulous Fakahatchee Strand Preserve State Park, Corkscrew Swamp Sanctuary, Florida Panther National Wildlife Refuge, and CREW Marsh.

And then trailing more than one hundred miles west off the southern tip of mainland Florida are the rocky Florida Keys, which are completely unlike any other part of the state in flora, fauna, ambience, winter temperatures, and even culture. The average elevation is five feet above sea level, making the Keys particularly vulnerable to the ravages of hurricanes. Visit Key West during the Halloween Fantasy Fest, where body paint often replaces various articles of clothing, and see where bizarre becomes normal. Born-and-raised residents of the Florida Keys proudly call themselves *Conchs* and claim they live in a drinking community with a fishing problem. The term *Conch* originates back to the olden days. When a baby was born in the Keys, the proud parents would pound a stake into the ground in front of their home and place a conch shell on top of it. Florida doesn't stop at Key West either. Seventy miles farther west are the remote Dry Tortugas, now a national park, and where Fort Jefferson was built in 1846 to guard the mainland from pirates and conquistadors.

If you are a first-time visitor to Florida, take it all in. But first take the roads less traveled and

drive through small crossroads where time passes at a different pace than elsewhere in the state. See the real Florida before you go to Fantasyland. Make it a mission to visit the gold medal award–winning state parks that dot the entire state, where you can still see picturesque landscapes of natural Florida from predevelopment times. Florida also boasts outstanding national forests, parks, and preserves that offer exceptional outdoor experiences for people of all ages and abilities. There are hundreds of miles of long sandy beaches to choose from on both coasts, from Jacksonville clear around to Pensacola. Florida beaches range from those you can drive your car on, like sections of Daytona Beach, to wonderfully remote and beautifully pristine beaches like Cape Sable and Highland Beach in Everglades National Park. There's also the glitz and glamour of Miami Beach, where the nightlife doesn't begin until one o'clock in the morning. And don't forget the gorgeous beaches of the Florida Panhandle or the famous shelling beaches of Sanibel Island.

And finally, to complete your experience, there's another Florida that you have to see, and it can best be described as "Weird Florida." It's the Florida that includes implausible places and events, such as Spook Hill, where your car appears to roll up hill when you put it in neutral. Or there's the Skunk Ape Museum, if you believe they're lurking out there, and Coral Castle if you'd like to see what happens when a woman breaks a man's heart and he focuses all of his energy on limestone. There are also any number of quirky festivals well worth attending—most notably the Cooter Festival in Inverness, the King Mango Strut and the Bed Race in Coconut Grove, the Key West Fantasy Fest, the Swamp Cabbage Festival in LaBelle, the Worm Gruntin' Festival in Sopchoppy, or the Conch Republic Independence Celebration or the popular St. Patrick's Day Bar Stroll, also in Key West. If Pensacola's Interstate Mullet Toss Contest isn't quite absurd enough for you, then bring your diving gear and enter the Underwater Pumpkin Carving Contest held offshore of Key Largo.

Come find out for yourself what makes Florida so special and it will be a vacation that will linger in your mind and spirit for a lifetime. But if you can't make it, then turn the pages of this book to find fifty iconic things, people, places, and events that make Florida a rich and most wondrous place to visit and explore. Welcome to the Sunshine State.

FLORIDA ICONS

THE COCONUT PALM

If there is one single image that best portrays Florida's ambience, it is a coconut palm on a pristine sandy beach arching gracefully over the sea while its fronds sway in a balmy ocean breeze. To seafarers of old the coconut was a godsend. The fruits could be stowed for months in a ship's hold without refrigeration, and each contained highly nutritious "milk" and "meat" inside the nut. The shell of the nut cut in half makes a fine bowl or cup, and the dried husk around the nut can be burned for warmth or cooking. The fronds of the palm are used for thatched roofs, for matting on floors, as a handy broom, or they are woven into hats. The coconut also yields fine oil that can be used for cooking or lighting or as an ingredient in skin lotions and other beauty products.

The coconut palm *(Cocos nucifera)* originated in the South Pacific, but was transported by sailors and favorable ocean currents to tropical, subtropical, and warm temperate regions around the world, even as early as the first century. Portuguese sailors likened the shaggy husked nut to Coco, a mythical ghost-monster, and coined the name *coconut*. Dr. Henry Perrine first introduced the coconut palm to Florida on Key Biscayne in the 1830s. In the 1880s a ship hauling coconuts foundered miles offshore during a strong tropical storm. As the ship sank the coconuts broke free and drifted to southeast Florida, making landfall and germinating along the beach by the thousands. They became so prolific that, in 1909, they influenced the naming of Palm Beach County.

The coconut palm is easily the most recognizable palm in Florida, but a disease called lethal yellowing reduced its numbers in the state by the millions. New disease-resistant hybrids and varieties have been developed so, once again, a beautiful and longstanding symbol of Florida is being replenished.

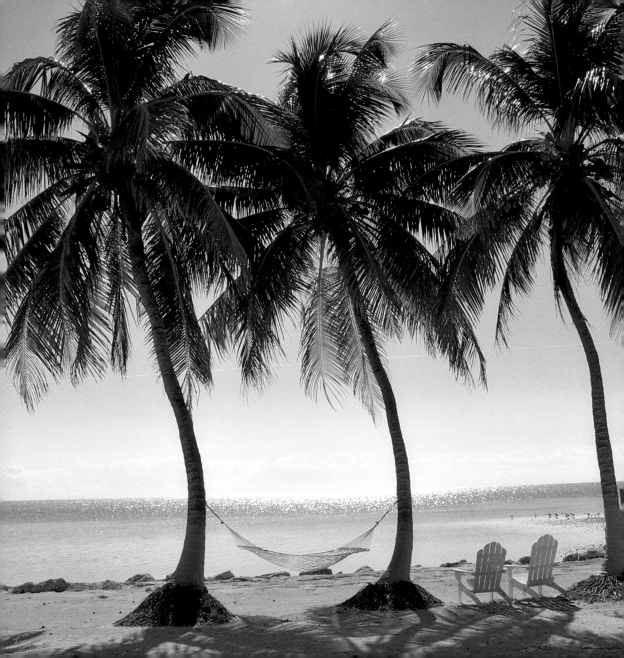

THE SUWANNEE RIVER

The Suwannee River invokes visions of Old Florida. It is a legendary river flowing with history and is an inspirational source of poetry and songs, the most famous of which is the official state song of Florida, *Old Folks At Home,* written by composer Stephen Foster in 1851. The song is best known for its opening verse, "Way down upon the Suwannee River."

Born in the Okefenokee Swamp in Georgia, the Suwannee flows 245 miles through eight Florida counties before reaching the Gulf of Mexico. Its major tributaries are the Alapaha, Withlacoochee, and Santa Fe Rivers, and there are more than fifty springs upwelling along its length.

When Spanish explorer Hernando de Soto led an army of men through the northern portions of Florida in 1539, he found Timucuan Indians living along the Suwannee. The Timucuans regarded the river as sacred, and it was they who gave it the name

Suwannee River State Park
3631 201st Path
Live Oak, FL
32060
(386) 362-2746
www.florida
stateparks.org
/suwanneeriver

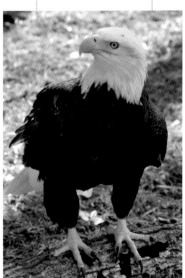

suwani, meaning "echo river" in their tongue. In the 1700s the Seminole, from the Lower Creek tribe in Georgia, traversed the Suwannee in dugout canoes forged from bald cypress trunks. Steamboats once plied the river as well, with the most famous being the *Madison,* which rests at the bottom of the river after being purposely sunk during the Civil War.

To see and enjoy this renowned river, visit the Suwannee River State Park in Live Oak. If you love real wilderness adventure, there's nothing like canoeing way down upon the Suwannee River. Paddling along remote and wonderfully beautiful stretches of the Suwannee will grant you access to untrammeled wild Florida at its very best.

The Suwannee River is not only an official Florida National Scenic Trail and designated as an Outstanding Florida Water, it is also one of the best rivers in the state to see our national bird, the bald eagle.

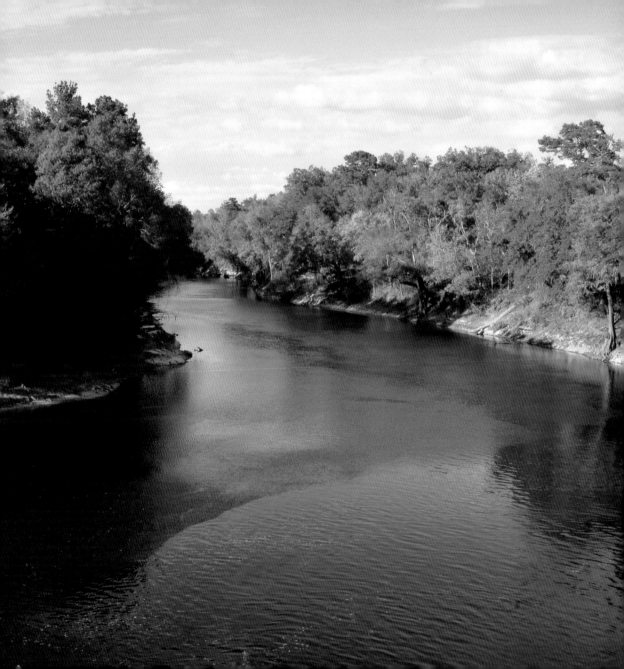

EVERGLADES NATIONAL PARK

Everglades National Park looms large in the Florida experience, attracting more than one million visitors a year. Most simply want to view the wildlife, resplendent scenery, and wondrous plant life. Others pine for outdoor adventure, fishing, canoeing, kayaking, camping, or merely solitude to escape city life and be close to nature. The Everglades Wilderness Waterway beckons canoeists and kayakers by connecting Everglades City to Flamingo along Florida Bay with ninety-nine miles of remote watery trails. And the pristine beach along Cape Sable west of Flamingo is one of the prettiest wild places in all of Florida to camp.

Politicians and developers once viewed the Everglades as nothing more than a worthless swamp to be drained for development, and that effort began in earnest when Napoleon Bonaparte Broward was elected governor in 1905. But efforts to drain the swamp proved daunting, and very luckily too, because Greater Miami could not

Everglades
National Park
40001 State Road
9336
Homestead, FL
33034
(305) 242-7700
www.nps.gov
/ever

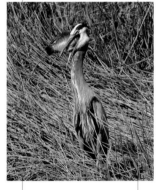

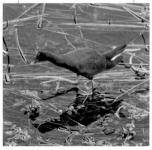

exist without the Everglades serving as a recharge area for the Biscayne Aquifer, where residents get their water.

After the Everglades suffered decades of misunderstanding and condescension, in 1947 President Harry Truman stood on a thatched platform at the northwest corner of the Everglades and dedicated our twenty-fourth national park in front of ten thousand onlookers. Truman spoke eloquently:

Here are no lofty peaks seeking the sky, no mighty glaciers or rushing streams wearing away the uplifted land. Here is land, tranquil in its quiet beauty, serving not as the source of water, but as the receiver of it. To its natural abundance we owe the spectacular plant and animal life that distinguishes this place from all others in our country.

It was the first national park dedicated solely for its biological wealth, and it is a designated World Heritage Site, an International Biosphere Reserve, and a Ramsar Wetland of International Importance. It is hardly a worthless swamp.

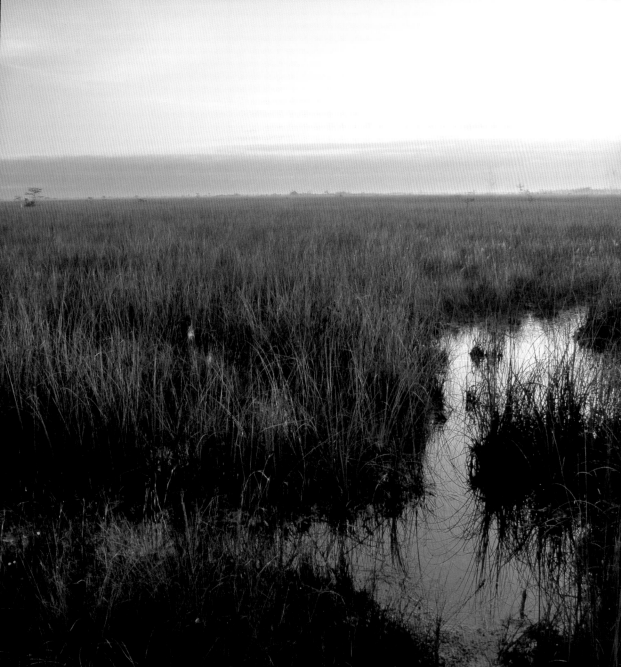

MARJORY STONEMAN DOUGLAS

Marjory Stoneman Douglas was born on April 7, 1890, in Minneapolis, Minnesota, and passed away peacefully in Miami, Florida on May 14, 1998. During those 108 years she lived a bountiful life, and her awards and honors are numerous and prestigious, including the highest honor that can be bestowed upon a U.S. citizen, the Presidential Medal of Freedom.

She is best known for her encomium, *The Everglades: River of Grass,* which she wrote in longhand at her Coconut Grove study at the age of fifty-seven. She was a gladiator at heart and an indefatigable champion devoted to saving the Everglades from developers and the whims of politicians. No other person did more to educate people, especially children, about the importance of the Everglades, and it was she who first defined the Everglades not as a swamp, but rather a fifty-mile-wide shallow river teeming with life.

Marjory Stoneman Douglas House 3744 Stewart Avenue Miami, FL 33133 www.historic preservation miami.com /douglas.html

I was humbled and greatly honored to be the recipient of the first Marjory Stoneman Douglas Award bestowed by the Florida Native Plant Society's Dade Chapter in 1982, which was presented to me by Marjory Stoneman Douglas herself. She later graciously invited me to her quaint 1926 cottage facing Biscayne Bay, which had no air-conditioning nor even a driveway, because she never learned to drive. Marjory asked from her kitchen if I wanted anything to drink, so I politely replied, "I'll have whatever you're having, Marjory." I surmised she would serve iced tea, or perhaps simply a glass of water, but when she walked into her living room she was holding a bottle of her favorite scotch and two glasses. No ice, no mixer—straight scotch. I had discovered her secret to longevity.

Her ashes were befittingly spread across the Marjory Stoneman Douglas Wilderness Area in Everglades National Park, the river of grass so dear to her heart.

KEY LIME PIE

The key lime *(Citrus aurantifolia)* is indigenous to the Indo-Malayan region, but was cultivated in Italy and France as early as the thirteenth century. It was later introduced into the West Indies by Spanish explorers and there were groves of trees in Haiti by the early 1500s. Outside of Florida it is popularly known as the Mexican lime.

Dr. Henry Perrine introduced the key lime to Florida from Mexico in 1838, and it has since become a prized dooryard fruit tree in the southern counties of the state. Be forewarned that if oils from the peel of a lime come in contact with the skin and then the skin is exposed to the sun the result will be painful blistering called "lime poisoning."

Key lime fruits are smaller than the more common Persian limes *(Citrus latifolia),* measuring only about one inch wide. Persian limes are harvested and sold while green so they can be differentiated from

Key West
Key Lime Pie
Company
431 Front Street
Key West, FL
33040
(305) 517-6720
www.keywest
keylimepieco.com

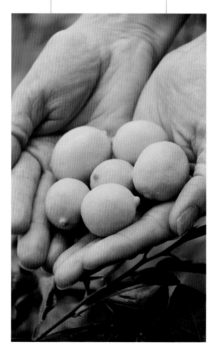

lemons in marketplaces. Key limes are harvested when fully ripe with a yellow peel. The peel is very thin, and the fruits are seedy compared to Persian limes, with a very distinctive flavor. The key lime is the source of delicious drinks, most notably the popular margarita, as well as the tantalizing key lime pie.

Key lime pie is Florida's official state pie and is effortless to make. Try this quick recipe (Persian limes may be substituted, but purists would say that's blasphemy):

5 egg yolks
1 14-ounce can sweetened condensed milk
½ cup lime juice
1 graham cracker crust

Preheat oven to 375°F.

In a bowl, combine egg yolks, sweetened condensed milk, and lime juice. Mix well. Pour lime mixture into graham cracker crust. Bake for 15 minutes. Cool pie to room temperature and then refrigerate. Before serving, top the pie with meringue and brown the top in the oven. Enjoy!

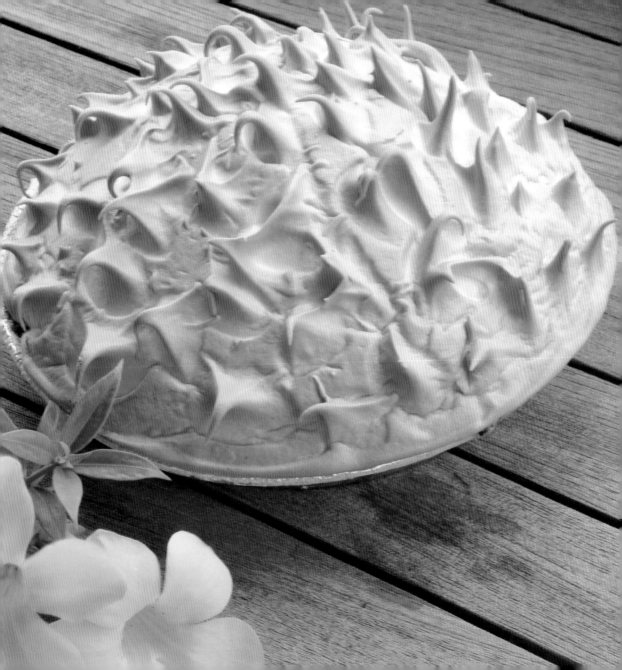

FAIRCHILD TROPICAL BOTANIC GARDEN

David Fairchild was a plant collector extraordinaire who authored books about his worldly travels, most notably *The World Was My Garden* (1938) and *The World Grows Round My Door* (1947). He built a modest home in Coconut Grove, which he would later call The Kampong, a name he took from his travels in Java. Fairchild originally had plans to be an entomologist and was preparing for a trip to Italy to study termites when he met Barbour Lathrop, a moneyed benefactor who talked him into becoming a botanist, and even funded his studies in Bonn, Germany.

As fate would have it, an attorney named Robert H. Montgomery loved plants and plant collecting, so he established an eighty-three acre garden in Coral Gables in 1936 and named it to honor his friend, David Fairchild. Thus, Fairchild Tropical Botanic Garden was founded. Today it remains a premier public garden, displaying tropical plants from around the world, and has transformed into a lasting

Fairchild Tropical
Botanic Garden
10901 Old Cutler
Road
Coral Gables, FL
33156
(305) 667-1651
www.fairchild
garden.org

The Kampong
4013 South
Douglas Road
Miami, FL 33133
(305) 442-7169
www.ntbg.org
/gardens
/kampong.php

tribute to both Montgomery and Fairchild. The Garden got off to a grandiose start when the renowned Miami landscape architect, William Lyman Phillips, designed it, and included picturesque overlooks, vine pergolas, walkways, and a series of tranquil lakes.

Fairchild Tropical Botanic Garden plays a leading role in botanical research and conservation of tropical forests worldwide. The Garden also promotes education and offers a prodigious array of classes to the public about gardening, cooking, and painting, and even hosts educational fieldtrips to private gardens and Everglades National Park. Plant sales and special events are held throughout the year, including the popular Ramble that features food, music, plant sales, and artisans displaying their wares.

If you visit the Garden, be certain to take a tram tour, enjoy lunch at the Rainforest Cafe, and browse the charming gift shop. A visit to The Kampong should be on your itinerary as well.

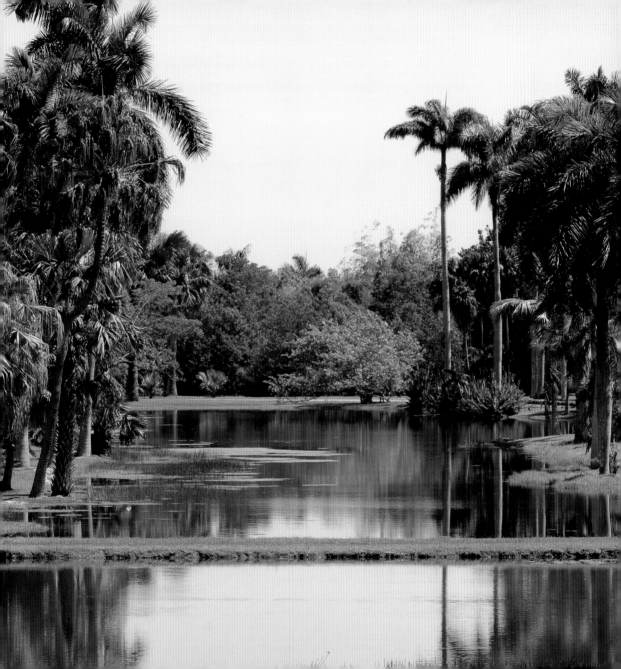

LAKE OKEECHOBEE

"I wanna live like a wildflower,
Find my place in the golden sun,
Sittin' on the banks of the Okeechobee,
Watchin' that river run . . ."
—Lisa Brokop, from the song *"Wildflower"*

Lake Okeechobee
Scenic Trail
Office of
Greenways &
Trails
www.dep.state.
fl.us/gwt/state
/lakeotrail

Picture in your mind one trillion gallons of water. That's how much water Lake Okeechobee is said to hold at its capacity and, at 730 square miles, it is the second-largest freshwater lake within the contiguous United States and the largest contained in one state. Known locally as the "Big O," the lake's name was derived from Hitchiti, the language of the Seminole, and means "big water." A group of aboriginal people once lived along the northeast corner of the lake during pre-Columbian times, and their tribal name, the Mayaimi, also translates to "big water."

Water overflowing Lake Okeechobee once nourished the vast Everglades to the south, but a twenty-foot-tall dike was built around the lake following a pair of hurricanes in 1926 and 1928 that killed thousands of people and completely annihilated lakeside towns. Today the top of the dike serves as a 110-mile circular trail for hikers and bikers and is part of the Florida National Scenic Trail. The rich black

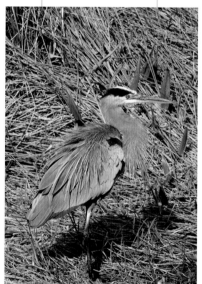

muck south of the lake is now planted in miles upon miles of sugarcane.

Kayakers and canoeists can traverse Florida via the Okeechobee Waterway, which connects the Gulf of Mexico to the Atlantic Ocean, but Lake Okeechobee should be given due respect by paddlers, because there are thirty miles of open water from shore to shore. Fishing can be outstanding, and anglers regard the Big O as the best lake in the state for lunker largemouth bass. Other fish sought by anglers include bluegill, black crappie, and catfish. There are numerous fish camps that rent boats if you'd like to wet a line and try your luck.

THE CABBAGE PALM

Florida may be the only state where people eat the official state tree. The ubiquitous and stately cabbage palm *(Sabal palmetto)* is found throughout Florida and, on the last weekend in February each year, the city of LaBelle in Hendry County hosts the official Swamp Cabbage Festival. So, if you have a powerful craving to eat the heart of Florida's state tree (called "swamp cabbage"), watch armadillo races, or even compete for the honor of Swamp Cabbage Queen, then you'll like this whimsical event.

Seminoles once built thatch chickees for their living quarters in the Everglades, which had a frame of cypress trunks, and the roof was an intricate arrangement of woven cabbage palm fronds. When built correctly, they last for decades. Chickees today are still constructed for private residences and also at local restaurants to use for outdoor dining with an authentic Florida flair. They are particularly common in the Florida Keys.

Swamp Cabbage Festival
25 E. Hickpochee Avenue
LaBelle, FL 33935
(863) 675-2995
www.swamp cabbagefestival .org

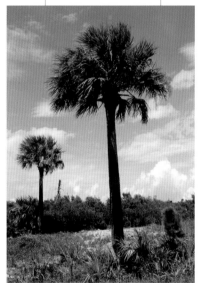

Birds are fond of eating the small, round, purple fruits of the cabbage palm, and Florida black bears will literally tear the trees apart for the nutritious terminal bud. The fronds also have thin brown fiber hanging from their segments, and this thread-like fiber is very popular among birds for nest building. Red-bellied woodpeckers, yellow-bellied sapsuckers, and Northern flickers are fond of excavating nest holes in the trunks of cabbage palms to raise their young. Even the trunks are used, as pilings for docks and lakeside boathouses.

The cabbage palm is widely planted in the Florida landscape, especially as a street tree and around state government buildings. It is very cold-tolerant and drought-resistant and withstands salty sea breezes, making it a good choice for landscaping in a wide variety of situations. The cabbage palm is also the state tree and state symbol of South Carolina.

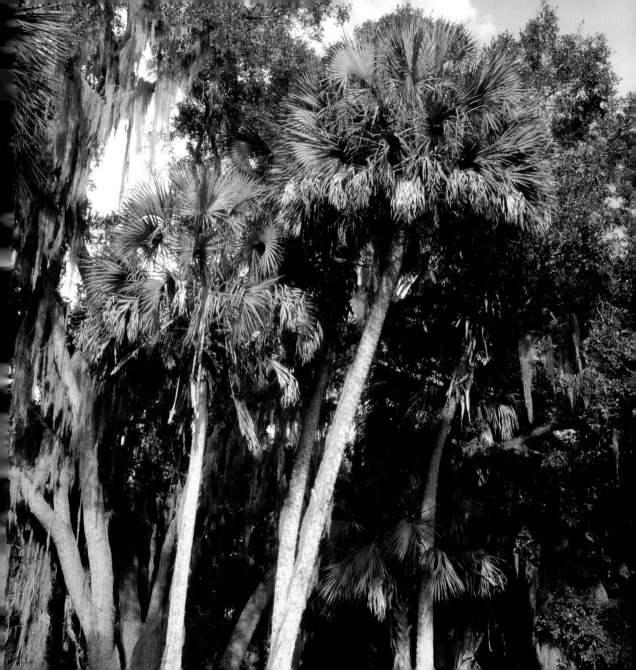

WORM GRUNTING

Gail Arnett is a worm grunter who wakes up long before sunrise, when most people are asleep, and drives out to the flatwoods surrounding Sopchoppy in the Big Bend area of the Florida Panhandle. She has lived there all her life. In the predawn darkness she pounds a stout hardwood stake into the ground and begins rubbing a thick iron bar across the top of it. This makes an oddly eerie grunting sound that resonates through the woods and sends vibrations deep into the soil. Earthworms come wriggling to the surface as if they've been electrified. Then she gathers them to sell for fishing bait.

To get to know the town of Sopchoppy you must first know its past. The name comes from two Creek words, *sokhe,* or "twisted," and *chapke,* meaning "long." Twisted and long aptly describes the Sopchoppy River on which this 1853 Florida town was founded. Sopchoppy's roots go deep like

*Worm Gruntin'
Festival
Downtown
Sopchoppy,
Florida
www.worm
gruntinfestival
.com*

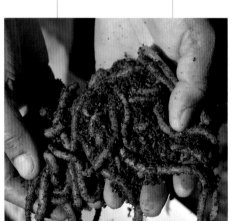

their earthworms, and residents claim there are one million earthworms per acre wriggling around in their soil. And grunting them out of the ground is Sopchoppy's claim to fame.

This method of harvesting earthworms is still used by a small handful of locals around Sopchoppy to earn a meager income. The whereabouts of worm grunters is advertised by signs along the roadside in front of their homes that read WORMS FOR SALE, or simply WORMS. Stop and buy some and take a cane pole down to the river and sit a spell. It won't really matter if you don't catch anything.

You'll also want to attend the Worm Gruntin' Festival held on the second Saturday of April each year, where you can enjoy worm grunting demonstrations, live music, a horseshoe contest, the crowning of the Worm Gruntin' Queen, and even a worm eating contest. They say they're nutritious. Wash them first.

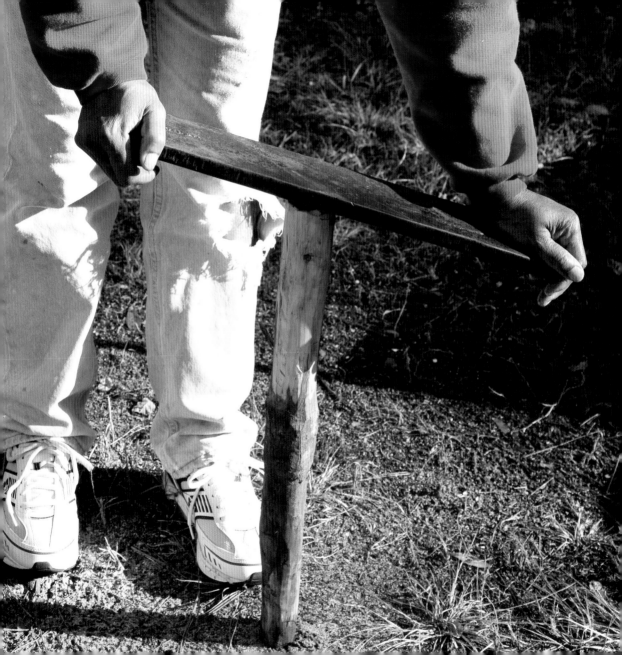

SAINT AUGUSTINE

Admiral Pedro Menéndez de Avilés is directly responsible for the city of St. Augustine, which he founded in 1565 at the age of forty-six and named San Agustín because he landed on August 28, feast day of Augustine of Hippo. Menéndez was a Spanish conquistador who sailed galleons to the New World to claim land for Spain. When French soldiers built a fort along the St. Johns River, the Spaniards viewed it as trespassing, so Menéndez established a fort made of coquina rock at present-day St. Augustine. Without ado the French set out to attack the Spanish fort by ship, but a hurricane ravaged the fleet, offering Menéndez the opportunity to besiege the French fort by land. Menéndez took 245 French soldiers prisoner and had them killed at a beach fourteen miles south of St. Augustine. That area today is known as Matanzas, Spanish for "killing" or "slaughter."

St. Augustine is a quaint coastal town that

Castillo de San
Marcos National
Monument
1 South Castillo
Drive
St. Augustine, FL
32084
(904) 829-6506
www.nps.gov
/casa

Anastasia State
Park
1340-A State
Road A1A South
St. Augustine, FL
32080
(904) 461-2033
www.floridastate
parks.org
/anastasia

is literally steeped in history. Indeed, practically everywhere you look there is history. Besides Castillo de San Marcos, the only seventeenth-century fort that still exists in the United States, there is also the oldest wooden schoolhouse in the country, and the Cathedral-Basilica, where the first Catholic congregation met on the North American continent. In the old part of town you will find the Prince Murat House, built of coquina around 1790, and the circa-1740 Tovar House, which now houses a military history exhibit.

Besides being historic, the city of St. Augustine offers excellent dining and shopping opportunities as well as beautiful sandy beaches, world-class fishing, and Anastasia State Park, where Spaniards quarried the coquina to build Castillo de San Marcos, completed in 1695 with the aid of Cuban stoneworkers and Native Americans. Even if you're not a history buff you will enjoy St. Augustine.

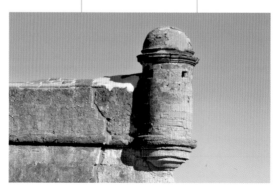

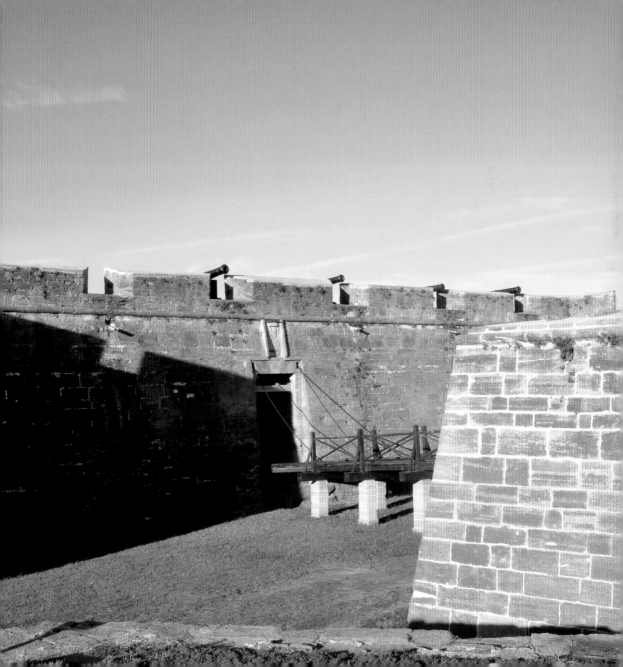

THE AMERICAN ALLIGATOR

No other animal in Florida is as well-known or more synonymous with southern swamps than Florida's official state reptile, the American alligator *(Alligator mississippiensis)*. The crocodilian family is ancient, dating its lineage back 170 million years when forty-five-foot-long leviathans crept through primeval swamps. Today more than one million alligators reside in Florida, and there is now a legal harvesting season for hunters who possess a special permit. The meat, hide, and skulls are valuable commodities.

Alligators are not without their fanciful stories. After reputedly warding off many large alligators while canoeing in Florida, famed naturalist William Bartram penned in his book, *Travels* (1791), "I began to tremble and keep a good lookout; when suddenly a huge alligator rushed out of the weeds, and with a tremendous roar came up and darted as swift as an arrow under my boat, emerging upright on my lee quarter with open jaws and belching water and smoke that fell upon me like rain in a hurricane."

With sincere regrets to Mickey Mouse, more people come to Florida to see an alligator than any other animal. Although it is far more rewarding to see them in the wild, many Florida roadside attractions display captive alligators. Despite fanciful exaggerations, the largest American alligator ever recorded in Florida was seventeen feet, five inches long. To find one in excess of twelve feet today is quite exceptional. Large American alligators are undoubtedly dangerous and should be treated with due caution. Between 2001 and 2007 thirteen people were killed by alligators, and twelve of them met their gruesome demise in Florida.

Some of the best places to view alligators in the wild are Shark Valley and Anhinga Trail in Everglades National Park, or around the Oasis Ranger Station in the Big Cypress National Preserve, but any Florida swamp will suffice.

Everglades
National Park
40001 State Road
9336
Homestead, FL
33034
(305) 242-7700
www.nps.gov
/ever

Big Cypress
National Preserve
33100 Tamiami
Trail East
Ochopee, FL
34141
(239) 695-1201
www.nps.gov/bicy

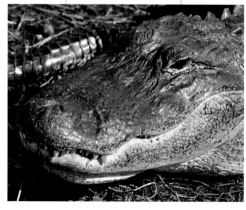

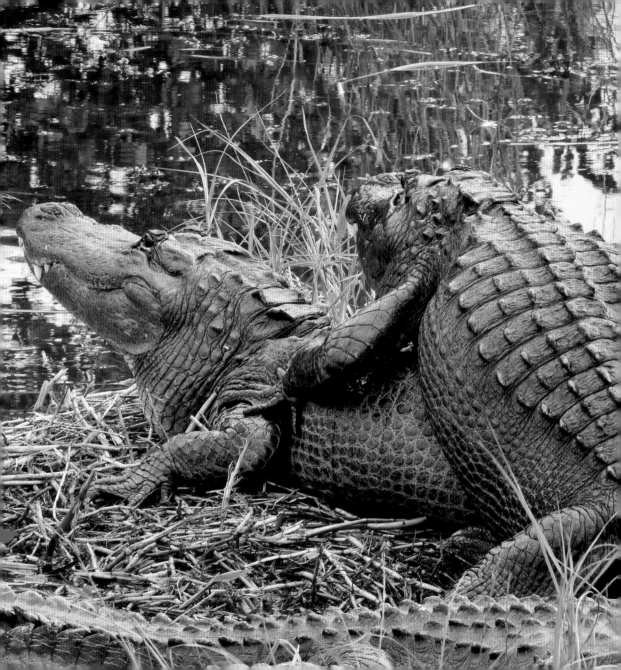

THE AMERICAN CROCODILE

Florida is the only state in the nation that has a resident population of American crocodiles, and the easiest place to see them is at Flamingo in Everglades National Park. Look for them lounging on the bank of Buttonwood Canal directly across from the marina store, or floating in the boat basin on either side of the weir. The one photographed resides in Nine Mile Pond, accessible by canoe or kayak.

The American crocodile (*Crocodylus acutus*) is a federal- and state-listed endangered species. Although crocodiles have a sinister reputation due to television documentaries showing enormous Nile crocodiles dragging fully grown wildebeest and zebras to a horrifying death as they migrate across rivers, the American crocodile prefers fish, crustaceans, turtles, waterfowl, and even alligators. If it makes you feel more at ease, there has never been a human encounter with an American crocodile in Florida, which is certainly not the case with the alligator.

Everglades National Park
40001 State Road 9336
Homestead, FL 33034
(305) 242-7700
www.nps.gov /ever

Crocodile Lake National Wildlife Refuge
P.O. Box 370
Key Largo, FL 33037
(305) 451-4223
www.fws.gov /nationalkeydeer /crocodilelake

The American crocodile lives in salty and brackish waters of South Florida, and there is a large breeding population in the cooling canal system of the Turkey Point Nuclear Power Plant along Biscayne Bay in southern Miami-Dade County. The Crocodile Lake National Wildlife Refuge on North Key Largo encompasses 6,700 acres of critical breeding habitat for the American crocodile, the endangered Schaus' swallowtail butterfly, and the imperiled Key Largo wood rat.

The American crocodile also occurs in the West Indies and along both coasts of Mexico south through Central America to northern South America. In Florida the species has been recorded at fifteen feet in length but is known to reach twenty-two feet in other parts of its range. It can be distinguished from the American alligator by the narrower snout, pale gray coloration, and bottom teeth that are visible when the mouth is closed. In other words, it has a toothy grin.

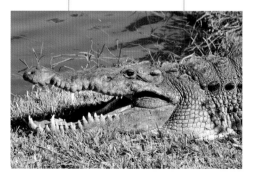

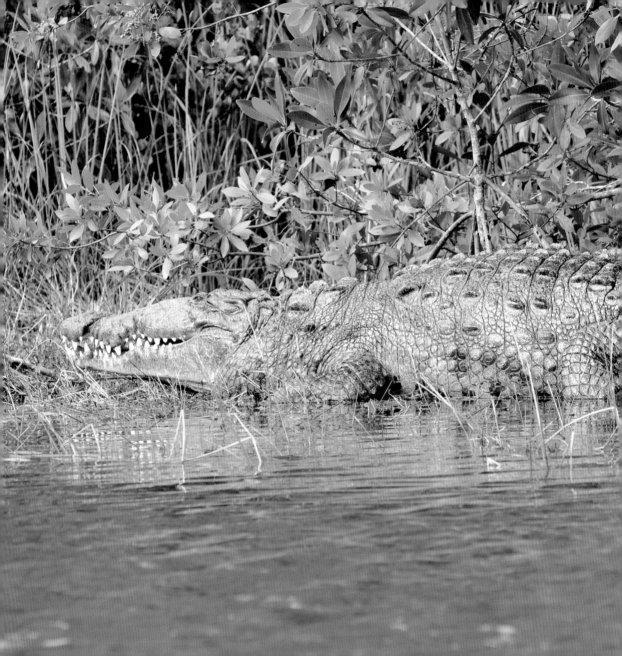

WALT DISNEY WORLD

Like Disneyland in Orange County, California, Walt Disney World in Orange County, Florida, was created by the renowned Walt Disney. He began searching for land in 1959 to create a theme park east of the Mississippi River and, in 1963 he flew over the thirty-thousand-acre Central Florida site and decided to buy it. Disney began purchasing large tracts of land, using dummy corporations such as M. T. Lott Real Estate, to keep landholders from realizing it was Disney purchasing the land, thereby keeping property prices from skyrocketing. On October 1, 1971, the doors to Walt Disney World opened to the world and ten thousand people rushed in to see the Magic Kingdom. Price of admission was $4.95. By the end of the first month, four hundred thousand people had walked through the turnstiles.

Today, Walt Disney World attracts a mind-numbing twenty-five million visitors a year to Florida, which is double the current number of visitors that Yellowstone, Yosemite, Grand Canyon, and

Walt Disney World
P.O. Box 10000
Lake Buena Vista,
FL 32830
(407) 824-4321
www.disney
world.disney
.go.com

The Disney
Wilderness
Preserve
2700 Scrub Jay
Trail
Kissimmee, FL
34759
(407) 935-0002
www.nature.org
/wherewework
/northamerica
/states/florida
/preserves
/art5523.html

Everglades National Parks receive each year, *combined.* Walt Disney World has become an economic boon for Florida, employing nearly sixty thousand people and ranked as the most popular tourist destination in the world.

If you like theme parks and want to have good wholesome family fun with the kids, Walt Disney World is every child's dream vacation. And what kid didn't grow up with Donald Duck, Mickey and Minnie Mouse, Bambi, Pinocchio, Cinderella, or Goofy? For those born later, there's Hannah Montana.

After your experience with animated wildlife, a remarkable place to see natural Florida and real wildlife is The Nature Conservancy's twelve-thousand-acre Disney Wilderness Preserve. Walt Disney World provided the preserve as a trade-off so they could fill protected wetlands on their property. The Nature Conservancy calls it "an innovative model of ecological restoration and one of the largest off-site wetlands mitigation projects ever undertaken in the United States."

FLORIDA CAVERNS

The first people to discover the caverns in Marianna, Florida must have been awestruck. It honestly doesn't make much geological sense that there should be caverns in Florida at all, yet there are hundreds of them. This makes Florida Caverns State Park an absolute must-see if you are visiting Florida's Panhandle. Florida Caverns is the only park in the state that offers public cavern tours where visitors can view resplendent formations of stalactites and stalagmites, along with other geological features called columns, rim stones, flowstones, and soda straws. Cave tours last about forty-five minutes and, for guests who are incapable of taking the tour, there is an audiovisual program inside the park's visitor center. Be certain to phone first to check on the availability of guided tours.

Calcium-rich water permeating through the rock drips from the cave's roof, forming what look like stony icicles (stalactites) as the calcium fuses

Florida Caverns State Park 3345 Caverns Road Marianna, FL 32446 (850) 482-9598 www.floridastateparks.org/floridacaverns

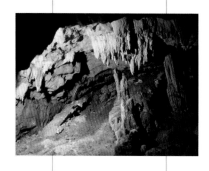

together. When water drips from the stalactites, it hits the cave floor directly below and another formation appears, the stalagmite. When these two formations merge after centuries of dripping water, they form columns.

Many caverns in Florida must be viewed with the aid of dive gear, but these should be left to exceptionally skilled divers, because too many novices have met an ill-gotten fate in these underwater caves. The majority of them are actually underground streams that run for miles before upwelling into springs. There is one particularly daunting aquatic cavern in Wakulla Springs State Park located in Wakulla County.

Although Florida's terrestrial caverns appear to be lifeless, they are home to bats, crickets, salamanders, millipedes, cave spiders, and more. Some cave dwellers are blind because they live in total darkness. Be sure to bring a camera and prepare to be totally dazzled.

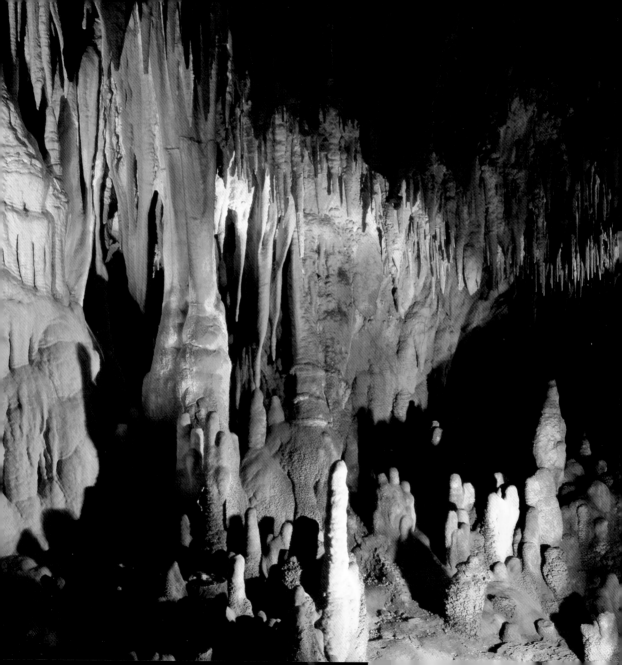

WINTER VEGETABLES

The vegetable growing season in South Florida is exactly the opposite of what it is everywhere else in the continental United States. Vegetables are planted in early fall, and harvesting takes place through winter into spring. The principal winter crops are tomatoes, zucchini, yellow squash, green beans, sweet corn, celery, and eggplant. South Florida is even called the "Winter Salad Bowl" and is the largest winter producer of sweet corn and tomatoes in the United States.

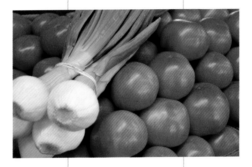

Winter farming in South Florida is not a sure thing, because some years the region experiences cold fronts that bring crop-killing freezes. Farmers battle this by spraying their crops with water throughout the night when there are freezing temperatures. This coats their crops with ice, thereby insulating the plants from even colder temperatures. Sometimes farmers even employ helicopters to hover over their crops in an attempt to keep killer frost from forming on the plants. This may sound insanely expensive, but Florida agriculture is a multibillion dollar business.

Much of South Florida is a bed of limestone near the surface, but a device called a rock plow enabled farmers to pulverize the surface rock into some semblance of soil to grow vegetable crops. This was both a blessing and a curse. It was a blessing to farmers but a curse to environmentalists, who watched as thousands of acres of pine rockland habitat were cleared for agriculture. After rock plows had their way with the land, where once there was a natural habitat harboring a diverse assemblage of indigenous plant species and associated wildlife, farmers planted a single species, often the tomato.

Today farmers water crops by drilling wells and then using a truck with a pump to blast water across the land. These contraptions are called water cannons, and they are quite a sight. Be on the lookout for rainbows in the mist they create.

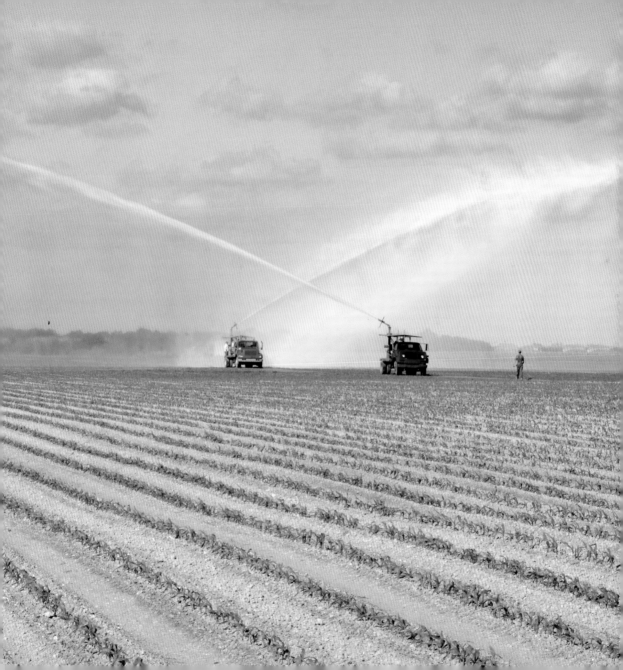

CORKSCREW SWAMP SANCTUARY

Florida has some fantastic swamps, and Corkscrew Swamp Sanctuary in Collier County makes it remarkably easy to see one without getting wet, muddy, or bitten by snakes. A 2.25-mile elevated boardwalk allows visitors to observe birds and other wildlife that live in pine flatwoods, prairie, and cypress swamp habitats. The plants are fabulous as well, with 130-foot-tall bald cypress trees towering above the swamp. Nearly two hundred resident and migratory bird species have been identified at Corkscrew, and this is quite apropos because Corkscrew Swamp Sanctuary is owned and operated by the National Audubon Society and is a premier destination for thousands of birders from around the world.

The Blair Audubon Visitor Center greets guests with an information booth and a marvelous gift shop that offers everything from binoculars, books, and bird feeders to jewelry and clothing. Corkscrew Swamp Sanctuary is regarded as the crown jewel of the National Audubon Society's preserves and is a sig-

Corkscrew Swamp Sanctuary 375 Sanctuary Road West Naples, FL 34120 (239) 348-9151 www.corkscrew .audubon.org

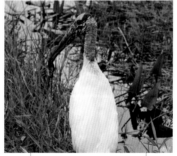

nificant nesting site for the endangered wood stork as well as a critical habitat for the Florida panther and Florida black bear.

Famed French ornithologist John James Audubon visited Florida in 1831 and 1832, where he discovered fifty-two new bird species for his distinguished work, *Birds of America.* Later, the National Audubon Society was formed out of outrage over the slaughtering of millions of birds whose feathers were used to adorn fashionable hats of the day. It seems anomalous that Audubon would be the society's namesake, because he himself shot birds by the thousands for identification and to accurately paint them.

Friendly and informative volunteers greet visitors along the boardwalk to offer assistance finding birds, often with spotting scopes trained on hidden barred owls or the trademark wood storks. Be advised that if you do not consider yourself a birder, a visit to this prodigious and renowned bird sanctuary may very likely transform you into one.

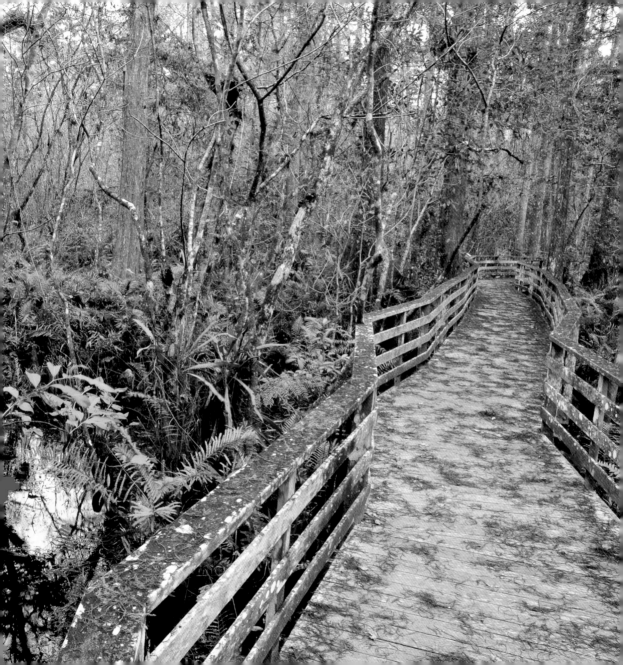

GREATER MIAMI

The city name was transliterated from Mayaimi, an indigenous aboriginal tribe that once inhabited the land at the northeast corner of Lake Okeechobee and who plied the Miami River from the Everglades to its mouth, where another tribe, the Tequesta, was based. In those days the Miami River had rapids and the water was crystal clear, but that all changed long ago.

Things to do and places to see in Miami rival those of any great city. There's sizzling nightlife at South Beach and sizzling forty-eight-ounce steaks at the original Don Shula's Steakhouse in Miami Lakes. Eat one and you become a member of the 48oz. Club and get your name on a wall plaque. There are ethnic restaurants galore, boasting cuisines from Kingston to Tokyo and from Buenos Aires to Berlin. Trek offshore and enjoy world-class deepwater fishing or stalk the shallow flats for bonefish, tarpon, and permit. Dive over marvelous coral reefs by day and enjoy performing arts by night.

Greater Miami and the Beaches www.miamiand beaches.com

Greater Miami has been a trendy place to live for such celebrities as Jackie Gleason, Madonna, Sylvester Stallone, the Bee Gees, Whitney Houston, and Oprah Winfrey, as well as Al Capone, O. J. Simpson, and Richard Nixon.

Today's Miami is a vibrant, ethnically diverse city that bridges the Bahamas, Caribbean, and the tropical Americas to the United States. For a cultural experience without needing a passport, Miami has much to offer. Or bring your passport and use Miami as a springboard for exotic vacations on cruise ships from the Port of Miami or jetliners from Miami International Airport. The world is at your fingertips either in, or from, Miami. For a romantic evening, choose a nice clear evening and drive over the Rickenbacker Causeway that connects to Key Biscayne. The Miami skyline from the Virginia Key Bridge is absolutely breathtaking at night.

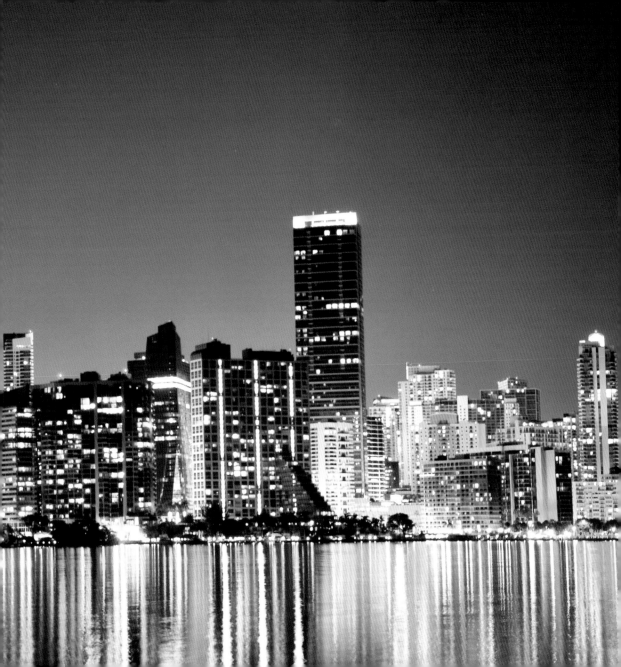

MARJORIE KINNAN RAWLINGS

In 1928, at the age of thirty-two, Marjorie Kinnan Rawlings purchased a seventy-two-acre parcel in a picturesque little Florida crossroads located in Alachua County called Cross Creek. Through her writings she would make Cross Creek more famous than any other small backwoods town in the state. Her first novel about Cross Creek was entitled *South Moon Under,* published in 1933 and nominated for a Pulitzer Prize. In 1942 she penned *Cross Creek,* a now famous autobiography about the Florida woods that surrounded her home and her kinship with her neighbors. However, prior to writing *Cross Creek,* she penned what would become her most endearing work, *The Yearling.* It is a heart-wrenching story of a deer fawn that was taken in and raised by a young lad named Jody. As the deer grew older it began to get into mischief. Eventually the boy's father shot the deer because it kept raiding

Marjorie Kinnan Rawlings Historic State Park
18700 S. County Road 325
Cross Creek, FL 32640
(352) 466-3672
www.florida stateparks.org /marjoriekinnan rawlings

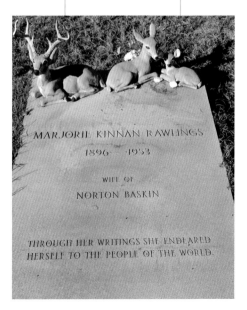

MARJORIE KINNAN RAWLINGS

1896 — 1953

WIFE OF
NORTON BASKIN

THROUGH HER WRITINGS SHE ENDEARED HERSELF TO THE PEOPLE OF THE WORLD.

the family's vegetable garden. The book won a Pulitzer Prize and became an MGM movie released in 1946.

Rawlings's home was listed on the National Register of Historic Places in 1970 and designated a National Historic Landmark in 2006, and it has been restored and preserved within the Marjorie Kinnan Rawlings Historic State Park. Park employees and volunteers offer living-history programs that depict 1930s-era life in Old Florida, and tours of the home are offered from October through July. Cross Creek nudges your inner soul, where time passes like cold molasses, so be prepared to step back to a simpler time. Sit in Marjorie's rocking chair and stay awhile.

Marjorie has many endearing quotes, but a personal favorite is about her perceived failure in life to find the right man: "They keep saying the right person will come along. I think mine got hit by a truck."

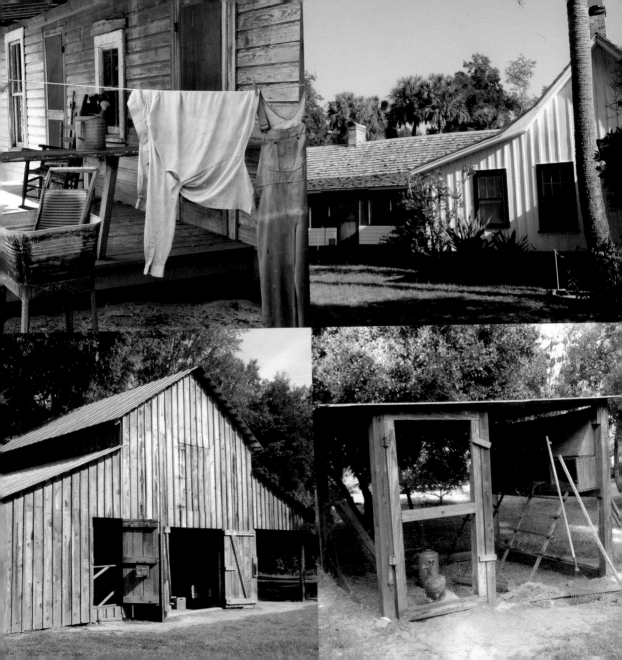

HURRICANES

The deafening shrill of the wind is what you remember most and the loud cracking as trees toppled to the ground, broken branches and debris slammed into your window shutters, and transformers exploded in a green flash as telephone poles toppled. Inside your home you prayed your roof would hold. And you try not to remember the distressing sound of neighbors who screamed for help during the lull of the eye before the fury began with an immediate and terrifying vengeance from the opposite direction.

Mention the word *Andrew* to anyone who was in southern Miami-Dade County on August 24, 1992, and he or she can tell some harrowing tales. The devastating Category 5 hurricane made landfall at Homestead with 160 mph sustained winds and gusts exceeding 200 mph that left behind $40.7 billion in damage, leaving 250,000 people homeless, and 1.4 million buildings without electricity. Yet, miraculously, only fifteen people died.

**National Hurricane Center
11691 SW 17th Street
Miami, FL 33165
(305) 229-4470
www.nhc.noaa
.gov**

Florida is the most hurricane-prone state, having been hit 114 times between 1851 and 2010. The Category 5 Okeechobee hurricane of 1928 killed more than 2,500 people when the storm surge breached the dike around Lake Okeechobee. The story wasn't so much about how many people died, but more that anyone survived at all. Then the Labor Day hurricane of 1935 pummeled the Florida Keys with the lowest barometric pressure ever recorded, killing 409 people. A train sent too late from Miami to rescue them was smashed to smithereens, and there was not one building left standing across forty miles of the Middle Keys.

In those days people relied on barometers, ship-to-shore radios, or observations of nature, such as seabirds heading inland, to alert them of approaching storms. Today the National Hurricane Center in Miami predicts the path and strength of impending storms, allowing time for life-saving preparations or even evacuation.

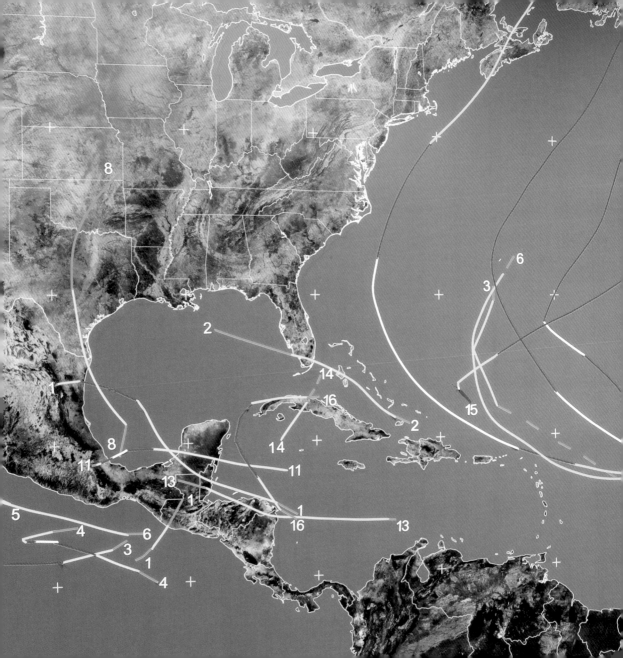

APALACHICOLA OYSTERS

There's an old saying that goes, "He was a brave man who first ate a raw oyster." We can only assume it was not a woman. Indeed, a raw oyster does not look the least bit appealing, much less appetizing, but oysters are the only seafood that tastes like the sea itself, and they have a cult following of connoisseurs.

While many people place raw oysters on crackers with a dollop of hot sauce, a deliciously simple way to enjoy them is to squeeze on a bit of fresh lemon or lime, bring the shell to your mouth, and then tilt it until the oyster slides off the shell. Eating raw oysters is not for the squeamish, and many people cannot get past even thinking about letting one slip down their gullet. And then there are the oyster-eating contests, where contestants gulp upwards of thirty dozen or more in fifteen minutes. The Florida Seafood Festival, held in November each year in Apalachicola, is a good place

Florida Seafood Festival
Battery Park on Bay Avenue
P.O. Box 758
Apalachicola, FL 32329
(888) 653-8011
www.florida seafoodfestival .com

to watch one of these contests, or to compete.

Apalachicola oysters are legendary, and restaurateurs as far away as New York claim they are the finest in the world, combining the perfect saltiness with classic texture and flavor. Apalachicola is the sole remaining place in the country where oysters are still harvested from the wild with traditional oyster rakes. Most Apalachicola oystermen are grizzled souls who love nothing more than raking oysters from Apalachicola Bay.

Shucking oysters is a skill, requiring more finesse than muscle, but eating raw oysters can be a dangerous proposition, especially for those with liver disease or hepatitis. The health risk is due to biotoxins, but health inspectors govern the industry by certifying the oysters are harvested from uncontaminated waters. There's even hard evidence that oysters increase sexual virility because they're high in zinc. So slurp away!

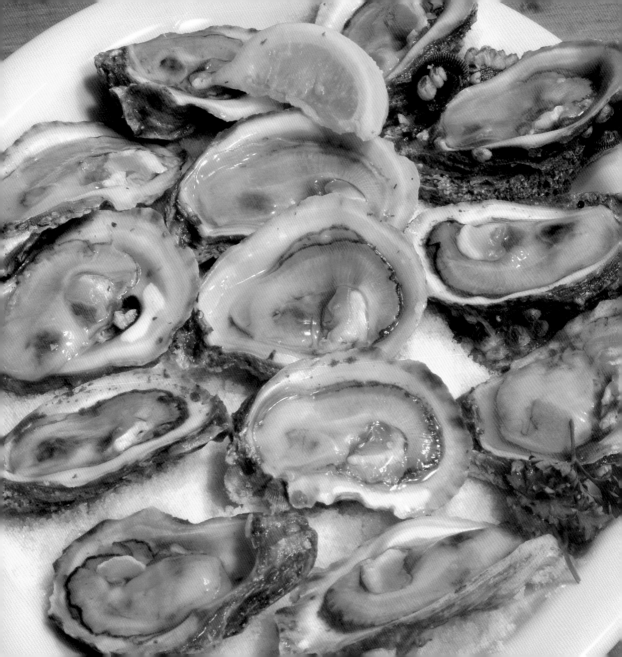

TARPON FISHING

Cast a lure or fly into the salt water surrounding Florida, it hardly matters where, and suddenly you feel a strong strike as a huge tarpon engulfs your offering. This is followed by a powerful searing run not unlike hooking a car driving down the turnpike, and then it goes airborne with a tremendous gill-rattling leap before hitting the water with an explosion you'd expect from a cow falling from an airplane into the sea. All you can do is brace for the second run and the ensuing aerial acrobatics. Then another. That's tarpon fishing, and it's big bucks for Florida's economy.

The tarpon, called the "silver king" by respectful anglers, is a common sport fish in Florida and is regulated by the Florida Fish and Wildlife Conservation Commission. Reaching weights well over two hundred pounds, it is a highly sought-after fish on light tackle, and even on fly. Currently there are twenty-nine Inter-

Robbie's of Islamorada
77522 B. Overseas Highway
Islamorada, FL 33036
(305) 664-9814
www.robbies.com

IGFA Fishing Hall of Fame & Museum
300 Gulf Stream Way
Dania Beach, FL 33004
(954) 927-2628
www.igfa.org

national Game Fish Association (IGFA) world records for tarpon and all of the major fly-fishing records have been set along Central Florida's west coast. The Florida record on conventional tackle is 243 pounds, and there's a 190-pound, 9-ounce tarpon on 16-pound tippet along with a 202-pounder on 20-pound tippet. Africa claimed the largest IGFA-certified tarpon on record when a 286-pound, 9-ounce fish was boated in 2003 at Guinea-Bissau.

If you'd like to feed enormous tarpon, then the place to go is Robbie's of Islamorada in the Florida Keys. Buy a bucket of fish there and walk out on

the dock. Below you will be a big school of tarpon just waiting for you to toss them an offering. Kids love it. Pay close attention to the impressive display of sunglasses and cameras on the wall, collected from the bottom of the bay next to the dock where people dropped them.

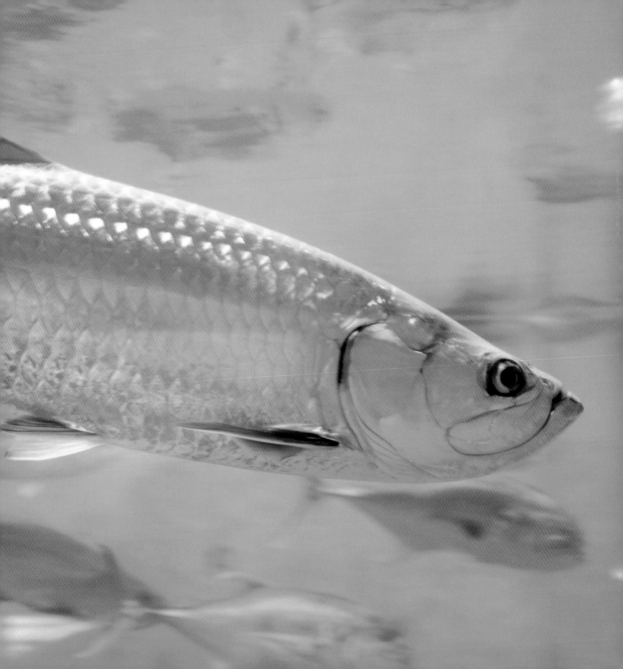

FLORIDA CITRUS

The sweet, enrapturing aroma of orange blossoms perfumes the air around Florida groves in springtime, and the fragrance is so enamoring that the orange blossom became Florida's official state flower in 1909. Between 1925 and 1953 a passenger train named the Orange Blossom Special brought tourists from New York to Miami, and orange blossoms have long been used in bouquets and tiaras for weddings. They are even said to bring good fortune and fertility.

Citrus originated in tropical Asia, but it is not known when the modern varieties were developed. Greek philosopher Theophrastus made the first reference to citrus in Europe in 350 B.C., and the popular sweet orange appeared sometime in the early 1400s. In Florida the renowned naturalist William Bartram found citrus trees growing along the St. Johns River as early as 1765. It is also known that the Seminole in Florida harvested sour oranges in the early 1700s to marinate venison.

Orange Blossom
Jamboree
www.orange
blossom
jamboree.com

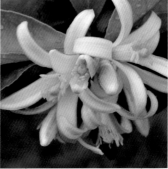

Before the turn of the twentieth century, commercial citrus groves were being planted in the sand hill country of lower Central Florida. The most popular varieties of oranges are Valencia, Hamlin, Navel, Temple, and Pineapple. The Tangelo, which many people mistake for an orange, is actually a cross between a tangerine and a pummelo (the ancestor of the grapefruit).

Florida is the largest producer of oranges in the United States and leads the world in grapefruit production, but diseases such as citrus canker and citrus greening, coupled with periodic winter freezes, continually threaten the industry. Orange blossom honey is another valuable product, as is, of course, fresh juice as a healthy source of Vitamin C. If you're a music aficionado then you'll love the Orange Blossom Jamboree held in Brooksville, Florida, in May each year, which features three days and two nights of camping and live music.

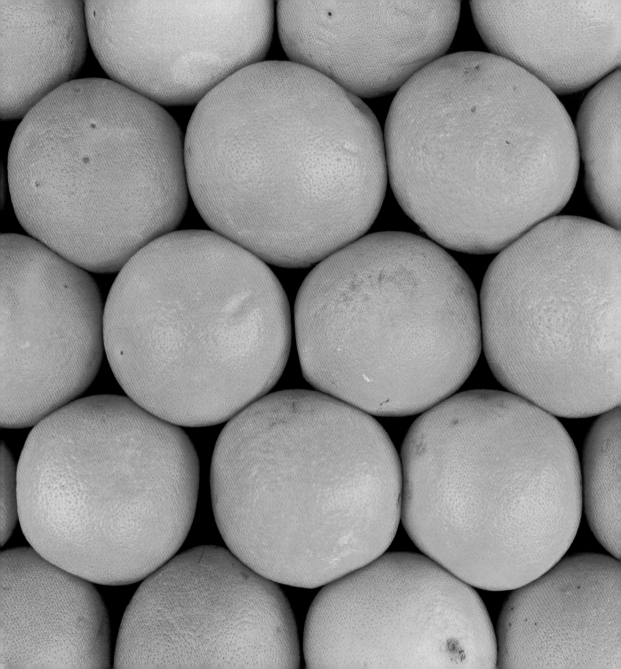

BOTTLENOSE DOLPHIN

The 1964 television series *Flipper* is what made the bottlenose dolphin *(Tursiops truncatus)* the most famous dolphin species in the world, and it is Florida's official state saltwater mammal. Bottlenose dolphins can be found in tropical and warm temperate waters worldwide and are a common sight along both coasts of Florida, as well as in tidal rivers and bays. They feed on fish, using ultrasound much like sonar to find their prey, and are adept at using team effort when hunting.

Dolphins communicate through complex sounds to help individuals identify one another, and they can produce sounds that stun fish to render them easier prey. Sometimes dolphins even chase mullet up on shore and then beach themselves so they can grab the flapping fish before they reach the water again.

Although they are very fishlike, dolphins are warm-blooded mammals, nursing their young with milk from mammary glands. They are highly intelligent social animals, which is why activists decry their captivity, where they are trained to perform tricks for public entertainment. Much of what biologists know about dolphins, however, comes from studies of captive animals.

Dolphins are caught and eaten in Japan, but when tourists see grilled dolphin being offered on restaurant menus in Florida, many are shocked, thinking they'd be ordering a fillet of Flipper. But the dolphin on Florida menus is a fish that shares the same name. Some restaurants call them mahimahi just to avoid the confusion.

Although it's easy to see wild bottlenose dolphins along Florida's coastlines, popular places to watch dolphin shows, or even swim with them, are at the Miami Seaquarium (Virginia Key), SeaWorld (Orlando), Florida's Gulfarium (Ft. Walton Beach), Gulf World Marine Park (Panama City Beach), and Theater of the Sea (Islamorada in the Florida Keys).

Miami Seaquarium
www.miami
seaquarium.com

SeaWorld
www.seaworld.
com

Florida's Gulfarium
www.gulfarium
.com

Gulf World Marine Park
www.gulfworld
marinepark.com

Theater of the Sea
www.theater
ofthesea.com

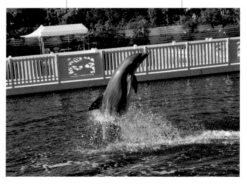

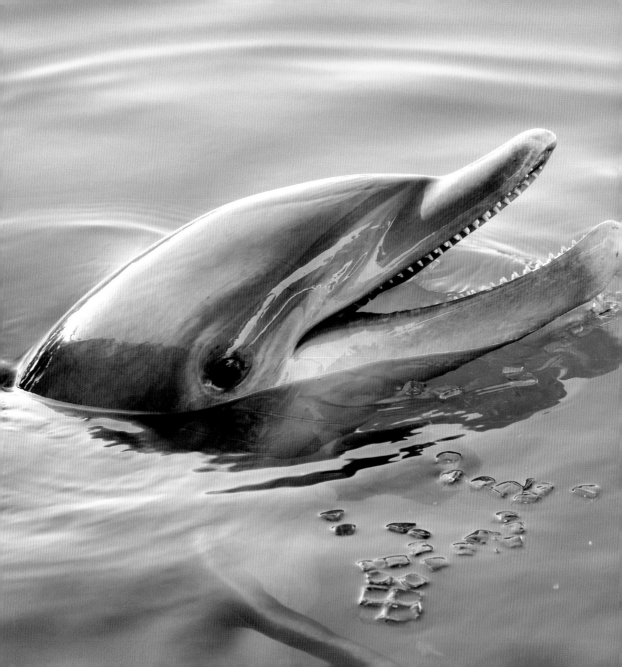

FLAGLER'S OVERSEAS RAILROAD

Henry Morrison Flagler has been called the man who invented Florida because he made such an impact on Florida's east coast and the Florida Keys. Deriving his fortunes from petroleum, Flagler turned his attention toward Florida because he realized there was untapped wealth to be made by building world-class hotels. He built an extravagant hotel in St. Augustine, transforming the quiet town into a ritzy destination for moneyed tourists. They arrived on the East Coast Railway that Flagler built to connect New York to Florida.

Flagler eventually took his railroad to Palm Beach, and then to Miami at the behest of Julia Tuttle, a wealthy pioneer woman who moved to her father's land bordering the Miami River in 1891. She began to take a leading role to establish a city there, so she offered land to Flagler and even sent fresh citrus flowers to him following the winter freeze of

Bahia Honda State Park
36850 Overseas Highway
Big Pine Key, FL 33043
(305) 872-2353
www.floridastateparks.org/bahiahonda

1894–1895. It inspired Flagler to bring his railway south, where he built the palatial Royal Palm Hotel in Miami. He quickly realized that taking his railway to the booming port of Key West could make him even wealthier, so he spent millions building forty-two bridges to span the rocky Keys for his Overseas Railroad. Flagler rode the final link of his railway to Key West in 1912, just a year before he fell down a marble staircase at the age of eighty-three and never recovered.

Twenty-three years later the Labor Day hurricane of 1935 destroyed Flagler's Overseas Railroad, but the railway foundation would be used for US Highway 1, called the Overseas Highway. Although the old bridges were replaced between 1978 and 1982, much of the original Seven Mile Bridge still exists and is used as a fishing pier. One old section of bridge can still be seen at Bahia Honda State Park.

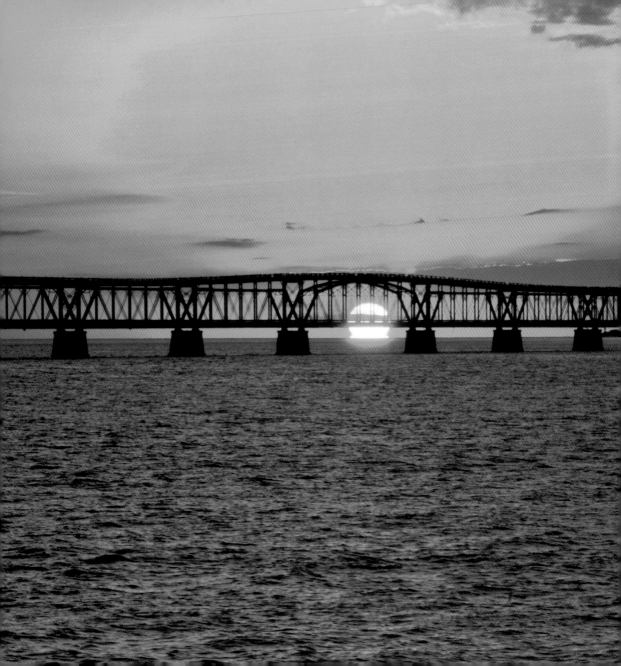

KEY WEST: THE CONCH REPUBLIC

"Key West" is a transliteration of the Spanish *Cayo Hueso,* or Bone Key, named because of the bones found strewing the shoreline by early sailors. Aboriginal Indians laid their dead on the shore so vultures would carry their spirits aloft.

Key West has a long history of wreckers who plundered ships that struck offshore reefs and visits by John James Audubon, poet Robert Frost, American playwright Tennessee Williams, and legendary writer Ernest Hemingway, who spent years there sitting on barstools in Capt. Tony's Saloon, the oldest bar in Florida. Hemingway's Key West home is now a historical site open to the public. The island is rife with history, including President Harry Truman's vacation home, dubbed the "Little White House." Later came Jimmy Buffett, crooning about cheeseburgers in paradise, and his entourage of admiring fans called Parrot Heads.

Key West is home to some kooky festivals, too. Halloween Fantasy Fest is particularly loony,

**Capt. Tony's
Saloon
428 Greene Street
Key West, FL
33040
(305) 294-1838
www.capttonys
saloon.com**

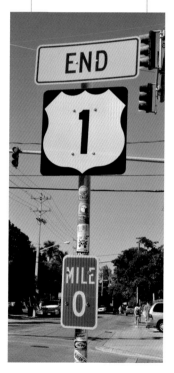

because many female revelers are so artistically painted it becomes difficult to tell they're topless. At the St. Patrick's Day Bar Stroll, partygoers get a free beer at ten different bars along the stroll. Want to drink a beer or two naked? Then go to the Garden of Eden, a clothing-optional bar on Duval Street. If that's not zany enough for you, at the Conch Republic Independence Celebration in April, the month when Key West proclaimed to have seceded from the Union in 1982, there's the Duval Street Drag Race, where squealing drag queens run merrily down the street in heels. The festival's motto: "We Seceded Where Others Failed."

After Key West recovered from Hurricane Georges in 1998, the city's message was "Back to Abnormal." And *abnormal* describes Key West perfectly. As further proof, there's a historic cemetery located dead center in the old town where a headstone for one B. P. Roberts (1929–1979) proclaims I TOLD YOU I WAS SICK.

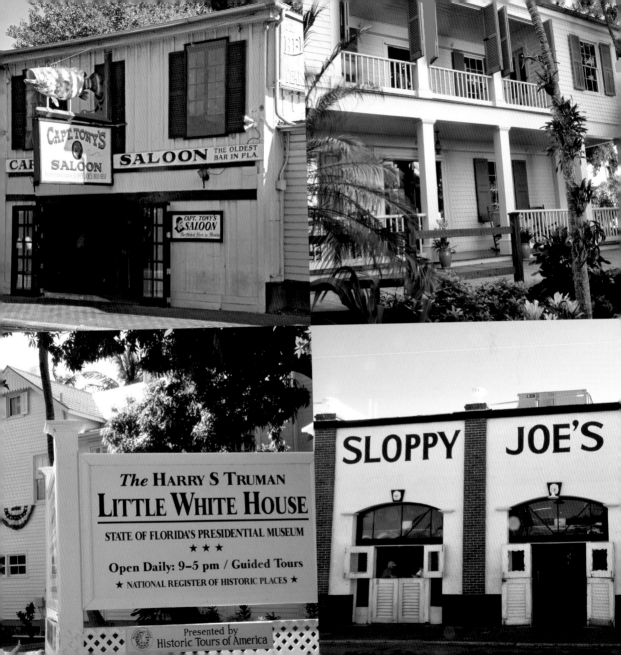

FLORIDA SCRUB-JAY

The Florida scrub-jay is one of the more difficult birds in Florida to photograph, mainly because it's often perched on your head or atop your camera lens. It is indisputably the friendliest bird in the state, which is why it is so beloved by visitors and residents alike.

The Florida scrub-jay is the state's only endemic bird, being found nowhere else, so it is a coveted species among birders who travel to Florida. If you want to see a Florida scrub-jay, some of the best locations to look are around the Matanzas National Monument in Volusia County, the Merritt Island National Wildlife Refuge in Brevard County, the Ocala National Forest in Lake County, Archbold Biological Station in Polk County, Oscar Scherer State Park in Sarasota County, Jonathan Dickinson State Park in Martin County, or at the W. P. Franklin Lock Recreation Area in Collier County. Regardless of where you go, look for the birds in and around scrub habitat, especially if it has burned in recent years.

The Florida scrub-jay is an omnivore, feeding on fruits, seeds, insects (especially caterpillars), frogs, lizards, small snakes, and even young mice. It is one of the few cooperative breeding birds in the country, where fledglings remain in family groups for several years to help rear young and defend their territory.

There is a campaign to replace the Northern mockingbird as Florida's official state bird with the Florida scrub-jay, not only because it is the only bird found exclusively in Florida but also because it would help bring greater awareness about its conservation needs. The Florida Fish and Wildlife Conservation Commission listed it as a threatened species in 1975 and the U.S. Fish and Wildlife Service followed suit in 1987. Its principal threat in Florida is habitat destruction due to development. With an estimated one thousand people moving to Florida each day, it's no wonder.

OCHOPEE POST OFFICE

Don't blink your eyes or you'll miss Ochopee. Located in southwest Florida's Collier County along Tamiami Trail (US 41) east of SR 29, the town of Ochopee's only real claim to fame is its post office, which is the smallest in the United States. The seven-foot, three-inch by eight-foot, four-inch building hasn't always been a post office. For years it had been a toolshed, but a fire in 1953 burned down a local gathering place called the Gaunt Company Store, which housed the local post office. The logical thing to do, more out of desperation than anything, was to transform the toolshed into a temporary post office, which would also serve as the Trailways bus stop. But time passes slowly in Ochopee and the shed is still the post office. However, with a 2008 census of only eleven residents, Ochopee doesn't really require much of a post office. The shed may even be too large.

Ochopee Post Office
38000 Tamiami Trail E
Ochopee, FL 34141
(239) 695-2099

The shed-turned-post-office wasn't always located where it currently stands, either. When Tamiami Trail was widened, the shed was moved to its current location with the aid of a wheelbarrow.

Busloads of tourists visit the Ochopee Post Office to mail cards and letters postmarked at the smallest post office in the nation and to get their picture taken standing by the quaint little building that resembles an outhouse more than a post office. The name *ochopee* means "big field" or "farm" in the language of the Seminole and Miccosukee, but farming disappeared in 1974 following the dedication of the Big Cypress National Preserve.

Ochopee is also home to the Skunk Ape Research Headquarters (why not?) where an Everglades Skunk Ape Festival is held each year, complete with a Miss Skunk Ape beauty contest for young ladies with a desire to embellish their résumé.

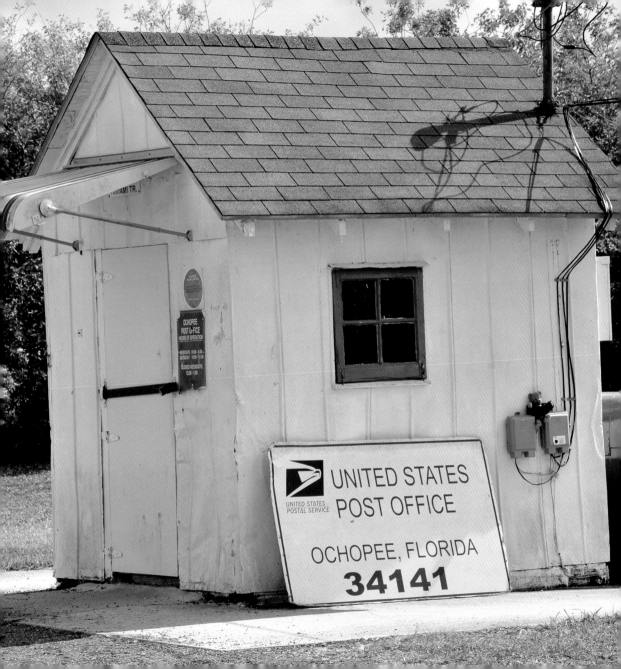

SMOKED MULLET

If there is one fish that exemplifies the very soul of Florida, it is the mullet, after it's been smoked. Florida crackers of old all had their own special smokers, using anything from relict refrigerators to wood boxes built over a fire pit. Noted journalist Al Burt even called Florida "the Mullet Latitudes."

The mullet is an herbivore and has the distinction of being the only fish with a gizzard—chicken-of-the-sea, if you will. Several species of mullet occur in Florida, but it's the fall runs of the striped mullet that get fish smokers all in a tizzy. Due to a gill net ban in Florida, most mullet today are harvested with cast nets. Once caught, the fish is beheaded and gutted, then split along the backbone (scales on) and opened flat, with the two halves connected by the belly. The fish is soaked in brine to "cure" the meat and then smoked for several hours

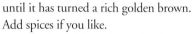

**Cedar Key
Seafood Festival
City Park
Second and
A Streets
Cedar Key, FL
32625
(352) 543-5600
www.cedarkey
.org**

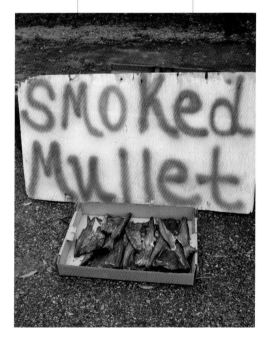

until it has turned a rich golden brown. Add spices if you like.

Smoking fish and meat has been around ever since fire was first discovered. Two smoking methods are used today. In hot smoking, the coals are inside the smoker with the fish. In cold smoking, the coals are separate from the smoker and the smoke enters through a pipe. Due to the lower temperature, cold smoking can take twelve to sixteen hours to cure fish and up to four days to cure meat.

Another Southern method of cooking mullet is to coat skinless fillets in corn meal and fry them in oil. Mullet roe (egg sacs) is another Southern delicacy often fried and mixed with eggs for breakfast. Regardless of how you prepare mullet, it is a Southern dish with its origin in Old Florida. Just look for roadside signs that say SMOKED MULLET.

CAPE FLORIDA LIGHTHOUSE

One of the places where Spanish explorer Juan Ponce de León made landfall in 1513 was on a sand barrier island beside a great glistening bay at the southeastern tip of the land he named La Florida and claimed for Spain. He named the island Santa Marta and wrote of finding a spring of sweet water. Today the island is called Key Biscayne.

The ocean floor is littered with ships whose captains misjudged the coral reefs that line the edge of the Gulf Stream, so, as an aid to navigation, a lighthouse was built on the southern tip of Key Biscayne in 1825. It remained in operation until 1878, when another light was built offshore on the treacherous Fowey Rocks.

On July 25, 1856, a renegade group of Seminole warriors stealthily approached the Cape Florida lighthouse. Living there at the time was John W. Thompson, the temporary keeper of the

Bill Baggs Cape
Florida State Park
1200 S. Crandon
Boulevard
Key Biscayne, FL
33149
(305) 361-5811
www.floridastate
parks.org/cape
florida

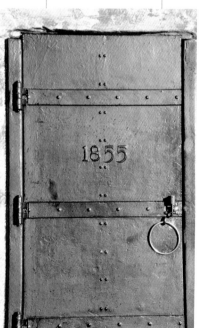

light, and his assistant, Aaron Carter. The Seminole attacked and set fire to a cottage and outbuildings along with the lighthouse door. Thompson and Carter barely had time to cut away the wood stairs as they scrambled to the top of the lighthouse, carrying with them a keg of gunpowder. As acrid hot smoke filled the lighthouse tower, the two men crawled onto the platform circling the light. Thompson was struck by a rifle shot, and another killed Carter. Thompson grabbed the keg of gunpowder and tossed it down the lighthouse shaft, where it exploded and extinguished the flames below. Thompson was later saved, and Carter was buried near the lighthouse.

The Cape Florida lighthouse is the oldest structure in Miami-Dade County and was placed on the National Register of Historic Places in 1971. It is preserved within scenic Bill Baggs Cape Florida State Park on the southern tip of Key Biscayne.

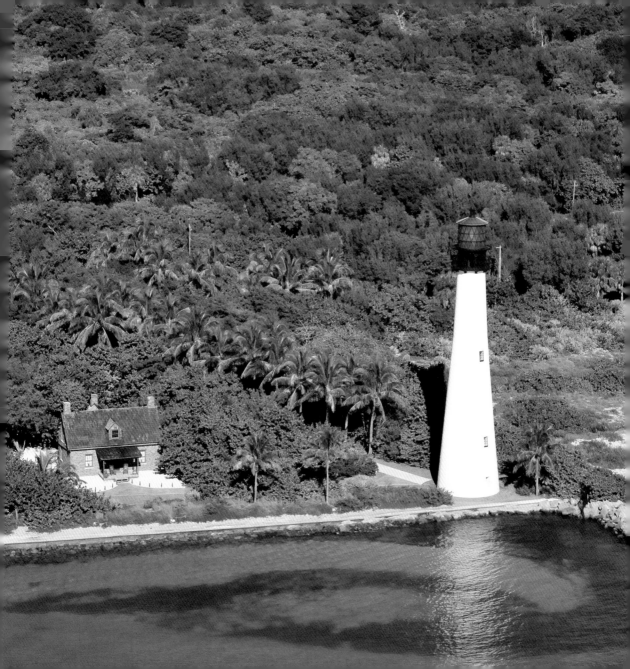

THE PAINTED BUNTING

There is hardly a more flamboyant bird in the United States than the male painted bunting, with its iridescent blue head, red eye ring, shimmering green back, and brilliant red breast. It's a kaleidoscope of color. The female is charming in her own right, being grass green above and yellowish green below, which makes for the perfect camouflage to hide from predators like keen-eyed sharp-shinned hawks. Other threats to painted buntings are feral or free-roaming cats and illegal trapping for the caged-bird market.

The only state where painted buntings overwinter is in Florida, and they typically show up during fall migration in the southern counties during September or October, and those that overwinter instead of continuing on to the tropics stay until April or May. Nesting occurs along the Eastern Seaboard from Central Florida to Georgia, South Carolina, and North

Painted Bunting Observer Team www.painted buntings.org

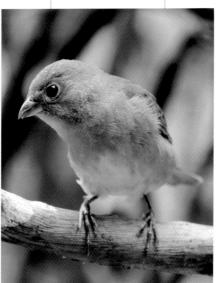

Carolina. There is a separate population that breeds from northern Mexico to Texas, Louisiana, Arkansas, and Oklahoma, but studies indicate that this population may represent a different species.

Eastern painted bunting populations have been declining for decades, principally due to habitat loss, so efforts are underway by a group of dedicated volunteers called the Painted Bunting Observer Team to band birds and then encourage people to report sightings in order to help document population patterns. Another important part of their study is to determine how important backyard feeders are as a food source. Feeders filled with millet, or a commercial wild birdseed mix, are readily visited by painted buntings, and it is sheer joy to watch them flit back and forth at feeders. If you've never seen one then you've been missing one of life's special treats.

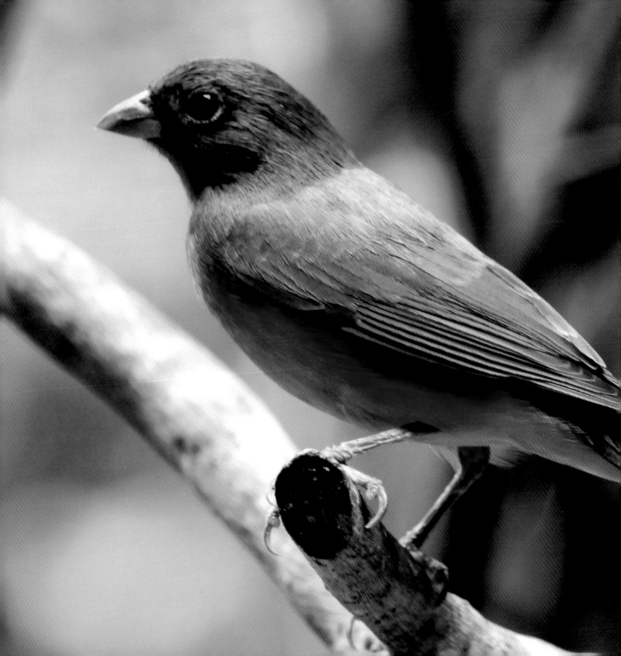

SOUTH BEACH ART DECO

Back in the 1920s Miami Beach was a swinging playground for the rich and famous, boasting luxurious hotels, glitzy casinos, scintillating nightclubs hosting wild parties, and unending over-the-top opulence. By the 1930s, organized crime figures moved in to claim some of the action, made most famously by Mafia hench-man Al Capone, who bought an ostentatious mansion on nearby Star Island. A photo of him fishing in Miami in his bathrobe was his alibi for the 1929 St. Valentine's Day Massacre, which Capone allegedly ordered after rivals machine-gunned his headquarters. Singer-actress Jennifer Lopez now owns his home.

Renowned actor-comedian Jackie Gleason filmed his *Jackie Gleason Show* on Miami Beach from 1964 until it went off the air in 1970. Shortly thereafter Miami Beach hit skid row and transformed from a city of lavish lifestyles to a destination for the homeless and destitute as well as the place where elderly retirees

Art Deco Welcome Center 1001 Ocean Drive Miami Beach, FL 33139 (305) 763-8026 www.mdpl.org

moved to bide away their golden years in the warm climate.

In the early 1980s, as developers began razing some of the historic hotels, the Miami Beach Preservation League was garnering support from business-people and politicos to help preserve the historic buildings and revitalize the area as a showplace for Art Deco. The undertaking got a major boost when the iconic pop artist Andy Warhol entered the scene.

Today the South Beach Art Deco District is once again an exuberant and fashionable locale where celebrities lounge around at see-and-be-seen outdoor cafes. Bikini-clad skaters rolling down Ocean Drive and night-clubs packed with the "Beautiful People" are what the Art Deco District is now famous for, and it exudes a sexy retro-chic charm.

There's an Art Deco Festival held in January each year and you'll also want to check out the Art Deco Welcome Center and the Miami Design Preservation League located inside the center.

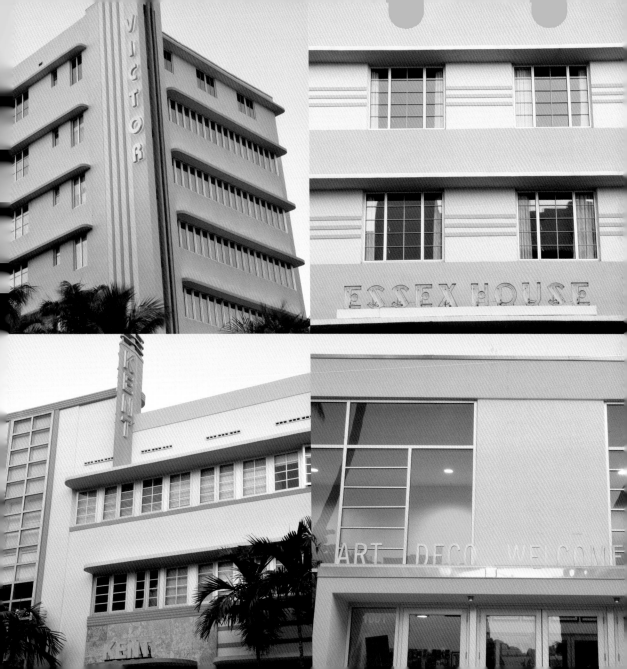

AMERICAN BISON

If you grew up watching episodes of *The Roy Rogers Show, The Gene Autry Show, Bonanza,* and *Gunsmoke* on television, you likely recall many scenes of American bison roaming the vast prairies of the Wild West, along with the requisite gunfights between cowboys and Indians and stagecoach robbery shootouts. Although no other animal symbolizes the Wild West better than the American bison *(Bison bison)*, what you probably didn't know is these hairy beasts roamed Florida, too.

During the Pleistocene epoch, about five hundred thousand years ago, when Earth was decidedly colder than it is today, the now-extinct Florida bison *(Bison antiquus)* and giant bison *(Bison latifrons)* roamed Florida, as evidenced by fossil records. Giant bison had horns that spanned more than six feet across. Saber-toothed tigers, Florida giant beavers, American lions, dire wolves, mastodons, and Paleo-Indians once roamed the Sunshine State as well. Herds of American bison were reported in North Florida

**Paynes Prairie Preserve State Park
100 Savannah Boulevard
Micanopy, FL 32667
(352) 466-3397
www.floridastate parks.org/paynes prairie**

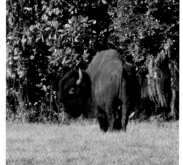

by the first Spanish explorers. Although they were hunted to extinction in Florida, American bison were reestablished from Oklahoma into Paynes Prairie Preserve State Park in Alachua County in the 1970s and are still present today.

Paynes Prairie was named for Payne, the eldest son of Ahaya the Cowkeeper, the eighteenth-century chief of the Alachuan Seminole. Although there are a variety of habitats at Paynes Prairie State Park, vast open prairies make up much of the twenty-one-thousand-acre park. American bison share these prairies with cracker horses and cracker cattle, leftovers from animals brought to Florida by Spanish conquistadors in the 1500s. The term "Florida cracker" was derived from the whips that made a cracking sound when used to round up wild cattle and horses.

Bison are also raised in Florida for meat, which is leaner and lower in cholesterol than either beef or chicken. It's advertised as the "original red meat," and sold under the misnomer, buffalo.

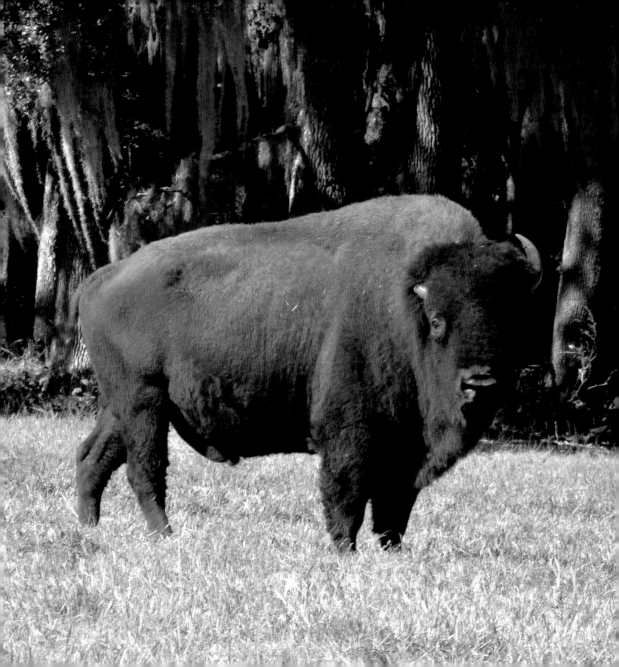

FLORIDA SPRINGS

The water is a refreshing 70 degrees Fahrenheit and can be as clear as window glass. If you've come to enjoy Florida's springs, there are many beautiful ones to choose from within any number of Florida's state parks. It would be difficult to say which spring is the most scenic, but Wakulla Springs State Park in Wakulla County must be high on the list, if not at the top. Others include Blue, Ichetucknee, Homosassa, Manatee, Rainbow, Rock, and Wekiwa Springs, all in state parks. There are also privately owned springs like Silver Springs, which is now a theme park offering glass-bottom boat tours.

People aren't the only visitors to Florida's springs. In winter big, lumbering West Indian manatees migrate upriver into springs to take advantage of the stable water temperatures and feed on succulent aquatic plants. Fish are abundant in the springs, too, so diving in them is like being in a huge aquarium. Largemouth bass, gar,

Florida State Parks www.floridastateparks.org

any number of small sunfish, and even the occasional Gulf sturgeon, can be seen in Florida springs. There are alligators, too, along with river otters and a plethora of other wildlife.

Tubing down spring-fed rivers is a popular summer pastime, and there are outfitters who rent rafts and inner tubes for this very purpose. Canoeing and kayaking are also popular, and there are liveries that will drop you off at one location and pick you up downriver later in the day, or even a week or more later if you're an adventurer who likes to camp.

Increasing numbers of Florida residents and tourists enjoy a variety of recreational activities on Florida's rivers and springs. This can harm the very resources they come to enjoy, so Florida has a strong commitment to protect these valuable natural resources for future generations.

The photograph is of Wakulla Springs in November.

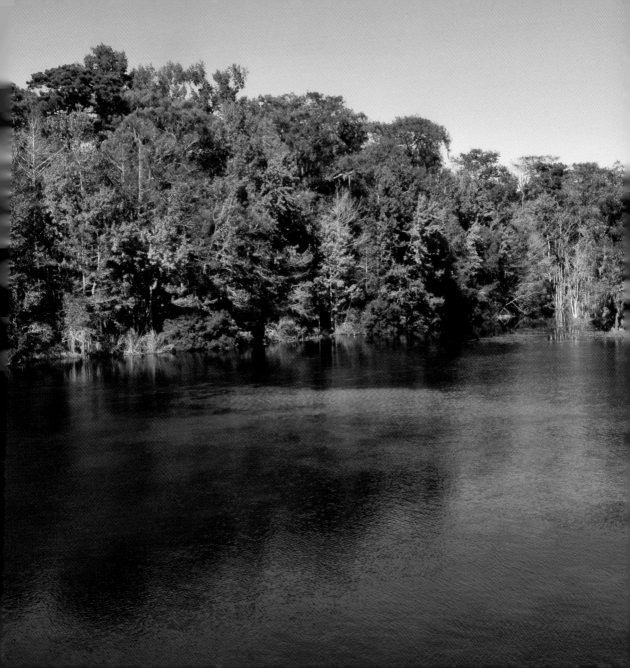

ROSEATE SPOONBILL

There is hardly a more captivating sight than a roseate spoonbill flying overhead. It's a vision that will remain in your memory for a lifetime.

The roseate spoonbill breeds in the southern parts of Texas, Louisiana, Florida and south through the Greater Antilles to Chile and Argentina. The birds' odd-shaped bill resembles a rounded spatula and is used to snare small fish, aquatic invertebrates, crustaceans, tadpoles, tiny mollusks, and even succulent aquatic plants. Beta carotene in their diet is what makes their feathers so stunningly pink, and it is derived from small crustaceans and algae.

Its luxuriant pink feathers almost caused the roseate spoonbill's demise during the plume-hunting years in the early 1900s, when bird feathers were high fashion on women's bonnets. Where there had been many thousands of roseate spoonbills in Florida, plume hunters decimated the population and, by the 1930s, there were no more than forty breeding pairs

Everglades
National Park
40001 State Road
9336
Homestead, FL
33034
(305) 242-7700
www.nps.gov
/ever

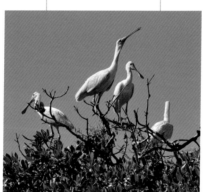

remaining anywhere in the state. Once laws were enacted to protect wading birds, and plume hunting became illegal, their population slowly rebounded.

Although spoonbills can be seen throughout much of coastal Florida, Paurotis Pond in Everglades National Park is a great place to look for them, especially in late winter and early spring. This is also where they nest in trees alongside hundreds of herons, egrets, and wood storks in early winter and spring. The Florida Bay population represents the majority of breeding colonies in Florida. In Everglades National Park also check Mrazek Pond, Snake Bight Trail, or on the flats in front of Flamingo at low tide. A rewarding way to see them is to paddle a canoe or kayak into Florida Bay west toward Snake Bight. Watching long-legged pink birds feeding on the flats or flying against a blue sky over the water while out canoeing in Everglades National Park: What's not to like about that?

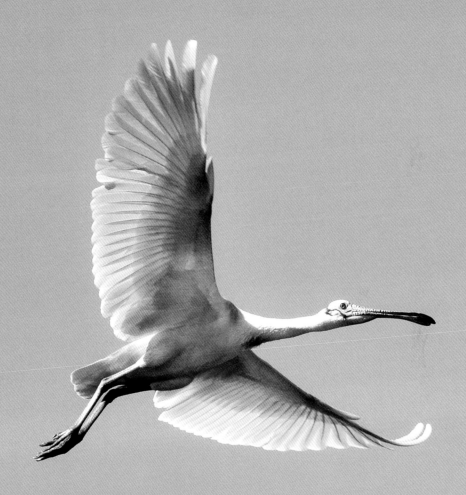

FLORIDA NATIVE ORCHIDS

Orchids are the most beguiling wildflowers, and Florida is the orchid state *par excellence* when it comes to numbers of native orchid species. Ask most anyone which state has the largest number of wild orchids and they'll understandably choose Hawaii, yet there are only 3 orchids indigenous to the Hawaiian Islands, and 108 in Florida. One reason Florida is so splendidly graced with native orchids is because a number of species from the Bahamas, the West Indies, and tropical America have found accommodating conditions in the swamps and hardwood forests of subtropical southern Florida, arriving naturally by wind-blown seeds. And there are huge tracts of prime habitat protected within national, state, and county parks and preserves in Florida. The crown jewel is the Fakahatchee Strand Preserve State Park in Collier County, which boasts nearly 50 native orchids, including the famous ghost orchid *(Dendrophylax lindenii).*

About half of Florida's native orchids grow as epiphytes, with

Fakahatchee
Strand Preserve
State Park
137 Coastline Drive
Copeland, FL
34137
(239) 695-4593
www.floridastate
parks.org/faka
hatcheestrand

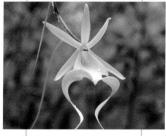

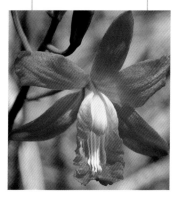

their roots clinging to the trunk and branches of trees, while the other half grow in the ground like normal plants. There are two species that are endemic to the state and found nowhere else.

The most majestic native orchid in Florida is undeniably the cowhorn orchid *(Cyrtopodium punctatum)* and there is one particularly magnificent specimen situated in a picturesque salt marsh within Everglades National Park. Its luxurious floral display from a distance resembles a swarm of bees, and it truly is a sight to behold. The pseudobulbs are shaped like cigars, giving rise to another common name, the cigar orchid.

The good news is that you do not have to wallow for miles through creepy snake-infested swamps to find Florida native orchids; some are roadside wildflowers that you can see while driving around the state, and still others can be abundant in open sunny meadows among a profusion of other wildflowers.

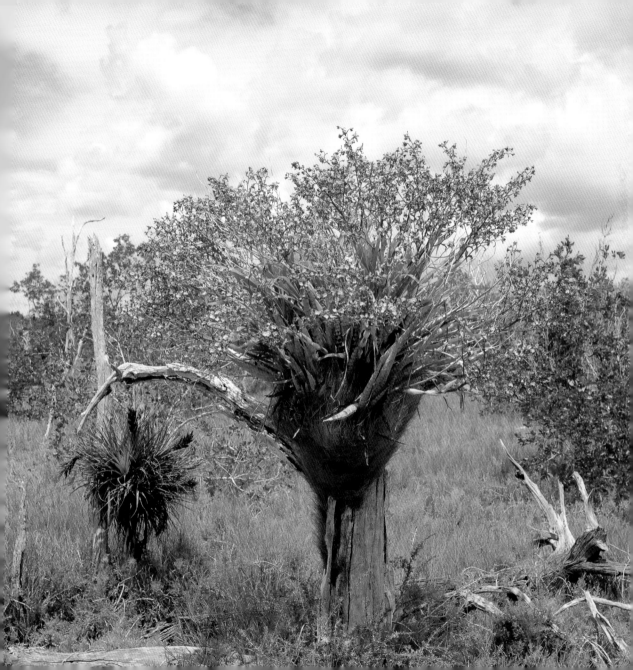

FABULOUS BUTTERFLIES

One of the most endearing insects is the butterfly, and Florida has 186 species to see and enjoy. The easily recognizable zebra longwing *(Heliconius charitonius)* is Florida's official state butterfly, designated by the state legislature in 1996. Except for the western Panhandle, the zebra longwing graces woodlands and urban gardens throughout the state with its coal black wings and intense yellow stripes. At night the butterflies form communal roosts, hanging onto one another in long chains with their wings closed, and they return to the same roost each night.

Visit most any national, state, or county preserve in Florida and you will find butterflies. Botanical gardens are good places to find them as well, or even along weedy roadsides and in vacant lots. You may not be alone either, because butterfly watching is becoming as popular as bird-watching. The North American Butterfly Association now has chapters throughout the country, with a number of them in Florida, where but-

Butterfly World
3600 W. Sample
Road
Coconut Creek,
FL 33073
(954) 977-4400
www.butterfly
world.com

North American
Butterfly
Association
www.naba.org

terfly lovers can meet people who share their passion. While butterfly watching can be a rewarding solitary affair, bringing a friend or joining a group allows you to share the joy. If you have children, bring them along too, or take them to Butterfly World in Broward County where you can walk among free-flying butterflies from around the world, along with hummingbirds, lorikeets, and other tropical birds.

Florida has some of the prettiest butterflies you can find anywhere on Earth, from large showy swallowtails to tiny fast-flying hairstreaks. Tropical specialties are what bring many butterfly aficionados to South Florida, where there are resident populations of such rarities as the Dina yellow, malachite, Schaus' swallowtail, Bartram's hairstreak, and the critically imperiled Miami blue.

You don't need much to become a butterfly watcher, either. A good pair of close-focusing binoculars and a field guide are all you need.

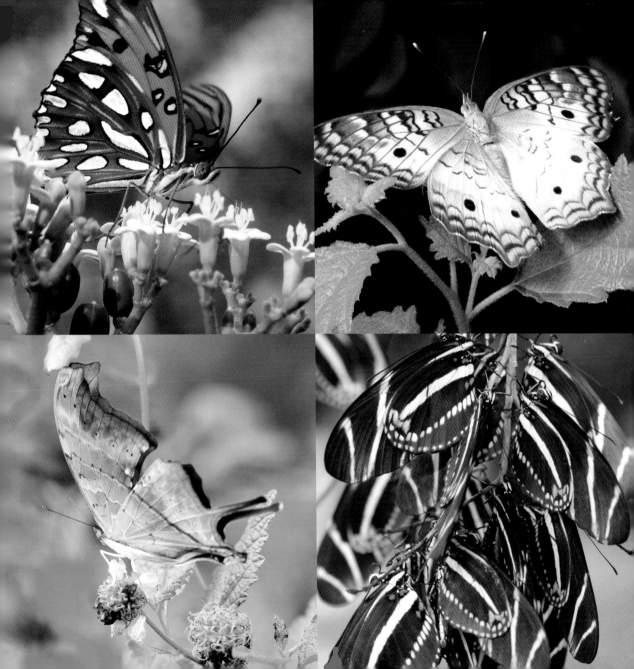

THE BILTMORE HOTEL OF CORAL GABLES

Inside the grandiloquent ballroom of the historic Biltmore Hotel of Coral Gables, allow yourself to imagine the music of Tommy Dorsey and the sashaying of dresses where Ginger Rogers and Judy Garland once danced the foxtrot. Bing Crosby crooned there, too. The Duke and Duchess of Windsor are counted among the royalty who have enjoyed the lavishness of the Biltmore, along with famed gangster Al "Scarface" Capone. Johnny Weissmüller, known most famously for his trademark ululating yell in his role as Tarzan, broke Duke Kahanamoku's world-record one-hundred-meter freestyle in the Biltmore Hotel pool.

As if creating the City of Coral Gables and founding the University of Miami weren't enough, land developer George E. Merrick joined company with hotel magnate John Bowman and built the lavish Biltmore. It opened in grand fashion in 1926, with northern tourists arriving on special trains called the Miami

Biltmore Hotel of Coral Gables
1200 Anastasia Avenue
Coral Gables, FL 33134
(305) 445-1926
www.biltmore hotel.com

Biltmore Specials. The Biltmore Hotel of Coral Gables exudes grandeur and boasts a world-class golf course, ten tennis courts, a preeminent spa, and eloquent dining.

The Biltmore is also haunted, or so the story goes. Gangster Thomas "Fatty" Walsh moved to Miami in 1928, after leaving New York one step ahead of the law for murder. He met up with Miami racketeer Edward Wilson, who had leased the entire thirteenth floor of the Biltmore Hotel to operate an illegal speakeasy and gambling hall. The two teamed up, but in 1929, during a gambling dispute in front of a roomful of guests, Wilson shot Fatty dead. Fatty's ghost is said to be skulking around the hotel opening elevators for guests. President Bill Clinton once stayed at the Biltmore, and when he tried watching a football game, the TV kept blinking on and off, so he went elsewhere to watch the game. Perhaps Fatty's ghost didn't like the Arkansas Razorbacks.

THE LUSCIOUS MANGO

If there is a fruit of the gods, then it undeniably has to be the mango, because no other fruit is as delectable or juicy. It's so juicy, in fact, that the best place to eat one is in the shower.

The mango *(Mangifera indica)* originated in tropical Asia and is the most highly revered tropical fruit in the world. Because it was so cherished and exalted in its native homeland since ancient times, Portuguese sailors introduced it to Africa and Brazil by the early 1500s. From there it didn't take long to reach Mexico and the West Indies. The first reported introduction in Florida was in 1833 on Cape Sable, but those trees died. Seeds were later imported from the West Indies to Miami around 1862 and the mango has been cultivated in southern Florida ever since. Florida leads the nation in commercial mango production, and there are now many cultivated varieties, each with its own distinctive quality, color, and flavor.

**Robert Is Here
19200 SW 344th
Street
Homestead, FL
33034
(305) 246-1592
www.robert
ishere.com**

Not all is rosy with the mango, however. It is in the Anacardiaceae plant family, which is notorious for its poisonous members, most notably poison ivy, poisonwood, poison sumac, and even the cashew and pistachio. Some people cannot handle a mango fruit without suffering painful skin lesions caused by the sap. But those who are sensitive to the sap can usually eat the sumptuous flesh without ill effects.

An absolute must-stop if you are in southern Miami-Dade County is Robert Is Here. This iconic open-air fruit stand is on the way to Everglades National Park and is where you can buy fresh mangos and many other tropical fruits and vegetables. You can even have them shipped directly to your home, or sent as gifts. While there, get in line for one of their tantalizing tropical fruit milkshakes. Robert suggests the mango-strawberry.

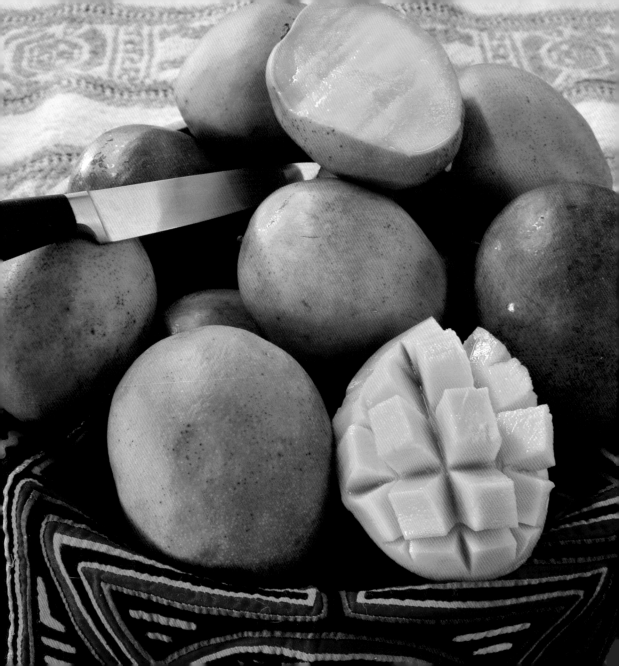

THE FLORIDA PANTHER

Meet Florida's official state animal. With only about one hundred remaining in the wild, the Florida panther *(Puma concolor coryi)* is one of the most critically imperiled mammals in North America. Their strongholds are in Florida's Big Cypress National Preserve, Fakahatchee Strand Preserve State Park, and Everglades National Park. There have been much better days for this big cat, and out of necessity to save it from extinction through inbreeding, eight females of the closely related Western puma *(Puma concolor stanleyana)* were released in 1995 into the Florida panther population to strengthen their gene pool.

If you were to see one of these magnificent cats in the wild, consider yourself blessed by luck. They are so rare that research biologists have placed radio collars on virtually all of them so they can monitor their movements or, sadly, find their carcass if they get hit by a car or meet some other unforeseen fate. In some stretches of roadways in southern Florida you may see tall chain-link fences stretching for miles on both sides of the road, with large underpasses constructed beneath the road for Florida panthers and other animals to use. This has decreased fatalities, but vehicles continue to be their biggest threat wherever they have access to highways.

The American alligator and Florida panther are the two top predators in the Everglades, but, while panthers will kill and eat young alligators, when alligators mature to full size, then the table is turned. Florida panthers eat plenty of white-tailed deer and feral hogs but also hunt rabbits, raccoons, opossums, and even large birds like wild turkeys, egrets, and herons.

You can spend a lifetime hiking in Florida's wilds and still never see a Florida panther, but just knowing they're there makes Florida that much richer.

THE DELECTABLE MARGARITA

If you want to give credit to, or perhaps lay blame upon, the person who first created a margarita, that distinction goes to Margaret Sames, an affluent socialite from Acapulco who went by the name Margarita. While with her husband and several Texas friends in Mexico, Margarita decided to concoct a new drink. Tequila was served straight up in shot glasses with salt and a slice of lime, but was never mixed into a drink. Call it fate if you will, but Margarita had a fancy for the French liqueur Cointreau, so she added some to tequila. She told of being pushed into the pool on many occasions by her friends because some of her concoctions were so abominable. Eventually she added lime juice and began tinkering with the amounts of the three ingredients until she came up with what is now the classic margarita.

Margaritas are served in a wide glass and classically with the rim of the glass dipped in lime juice and then coarse

Sundowners
103900 Overseas
Highway
Key Largo, FL
33037
(305) 451-4502
www.sundowners
keylargo.com

salt. Sometimes Triple Sec is substituted for Cointreau, but purists consider that an abomination. For a romantic experience visit Sundowners on Key Largo just before sunset and order a margarita on the rocks with Patron tequila.

Tequila is made from the Mexican blue agave *(Agave tequilana)* by removing the heart of the plant and then heating it to extract the sap, which is then distilled. If you would like to make your own original margarita, which has become a trademark Florida drink, here's how Margarita did it:

3 jiggers white tequila
1 jigger Cointreau
1 jigger lime juice.

Shake (never use a blender) and serve plain, on the rocks, or shaken with shaved ice. The coarse salt on the rim of the glass is optional.

But remember the ditty, "One tequila, two tequila, three tequila, floor!"

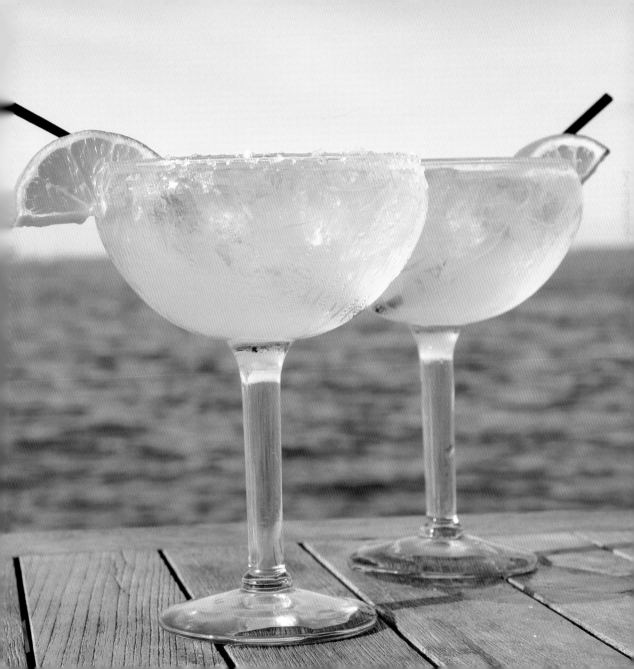

TROPICAL FLOWERING TREES

A plenitude of sunshine blesses the Sunshine State, along with more than its share of rain, creating the perfect environment for flowering plants. North Florida has its azaleas, camellias, gardenias, magnolias, dogwoods, and rhododendrons, but the warmer, subtropical southern counties are where tropical trees put on a show-stopping display of grandeur like no other part of the country.

Although all of Florida lies within the temperate zone, much of the state protrudes like a finger south across the ocean toward the equator, and the close proximity of South Florida to the warm waters of the Gulf Stream combine to create an environment where truly tropical plant species can survive outdoors.

There is a Royal Poinciana Festival held each year in June that begins at The Kampong in Coconut Grove, where attendees board a trolley that takes them through the Grove, Coral Gables, and

Tropical Flowering Tree Society www.tfts.org

South Miami in search of the best and most flamboyant royal poinciana of the year. But then there's a multitude of collectors of tropical flowering trees who have a genuine passion for the many unusual species from around the world, and they've formed a society so they can meet others who share their zealous affection for these tropical beauties. They are the Tropical Flowering Tree Society.

Take in the aroma of the blossoms of the cannonball tree, or become enamored by the radiant show of a floss silk tree in fall, or admire the many color variations of the frangipani, the flower used to make leis in Hawaii. Southern Florida is a tropical paradise, not only for tropical flowering trees, but also for those who are crazy about them. If you ever take in the heady aroma of the ylang-ylang, the source of Chanel No. 5 and Revlon Charlie perfumes, you'll be hooked on tropical flowering trees forever.

THE FLORIDA TRAIL

Wild adventure and breathtaking beauty await those who hike the Florida Trail, which extends from Pensacola Bay in the far western Panhandle and through the Big Cypress National Preserve at its southernmost end. Currently the Florida Trail meanders more than fifteen hundred miles, but the Florida Trail Association, with eighteen chapters throughout the state, continues to add new corridors through some of Florida's most fascinating wilderness areas. Some sections will require hiking along roadways and through cities, and hikers will also need permits to enter private land holdings, Indian Reservations, national preserves, and even two Air Force bases.

The crown jewel of the Florida Trail is the section that traverses the wonderfully wild Ocala National Forest, which is also an integral part of the Florida Statewide Greenways and Trails System. If you hike only one section of the Florida Trail, let this be the one you choose.

Florida Trail Association 5415 SW 13th Street Gainesville, FL 32608 (352) 378-8823 or (877) HIKE-FLA www.floridatrail .org

Most people hike the trail in sections but, for those wanting to thru-hike from one end to the other, e-mail the Florida Trail Association office by visiting their website and request a Thru-Hiker Inquiry Packet, which contains trip planning information, a list of required permits, a permit for the Big Cypress Seminole Indian Reservation, and the End-to-End certificate and patch application. Once you have successfully hiked the entire trail, you will receive a certificate of completion and a patch that you can proudly display and will make you the envy of your friends and fellow hikers.

Worried about getting impossibly lost? Members and devoted volunteers of the Florida Trail Association keep the trail cleared and blaze trees with orange paint to guide you on your journey. For your safety, be sure to sign in at register boxes wherever they occur. These provide useful data on trail use and are invaluable to rescue personnel should you need them. Happy trails!

KEY DEER

Lilliputian Key deer occur from Bahia Honda to Sugarloaf Key in the Lower Florida Keys, but especially on Big Pine Key and the sparsely populated No Name Key. Most biologists recognize them as a subspecies of the white-tailed deer although there have been attempts to relegate them as a distinct species. Adult males weigh between fifty-five and seventy-five pounds while females tip the scales at forty-five to sixty-five pounds. Their average height at the shoulders is only twenty-five to twenty-six inches. Their small size is due to natural selection from being isolated on rocky islands for thousands of years and it is believed they are descendants of white-tailed deer that crossed a land bridge during the Wisconsin glaciation between thirty thousand and ten thousand years ago, becoming separated from their mainland counterparts as the ice melted and sea levels rose.

Thirteen-year-old Hernando de Escalante Fontaneda was on board a ship

National Key Deer Refuge
28950 Watson Boulevard
Big Pine Key, FL 33043
(305) 872-2239
www.fws.gov /nationalkeydeer

sailing to Spain when it struck a Florida Keys reef in 1549. Everyone on board was captured and eventually killed by Calusa Indians, except Fontaneda, who was kept enslaved for seventeen years before being rescued. His writings are the earliest accounts of life in the Florida Keys, which included the very first written account of Key Deer: "But what was a great wonder to the captives who were there, and to those of us [held captive] in other places, was the existence of deer on the islands of Cuchiyaga, the town of which I have spoken [Big Pine Key]."

The hunting of Key deer was banned in 1939, and the 9,200-acre National Key Deer Refuge was established in 1957 to protect Key deer habitat. Key deer are friendly animals and have become quite urbanized, walking through residential areas without fear of humans. Drive carefully through their habitat because automobiles are their principal cause of death.

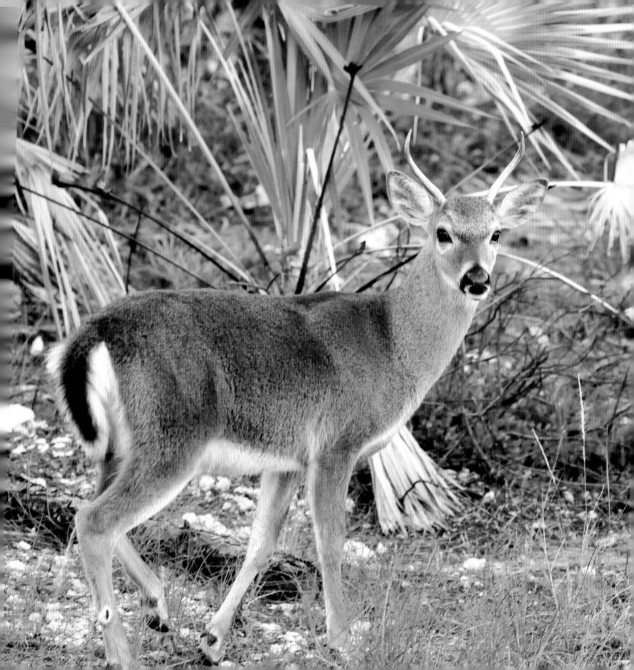

WEST INDIAN MANATEE

Once you've laid eyes on a West Indian manatee it becomes unimaginably hilarious how they were once mistaken for mermaids, those mythical half-woman, half-fish, beauties of the sea with shapely bodies and flowing blonde hair. Perhaps being at sea for many months while liquored up on rum is all it takes. Italian navigator Christopher Columbus sailed near Hispaniola in 1492 and reported seeing mermaids, even noting in the ship's log that they were "not half as beautiful as they are painted." He undoubtedly had seen West Indian manatees, and he most assuredly didn't expect mermaids to be hugely obese with facial whiskers and a big paddle-like tail.

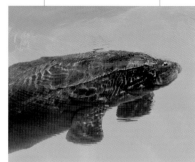

The West Indian manatee *(Trichechus manatus)* is the largest surviving member in the order Sirenia, a group of animals that also includes the West African manatee, Amazonian manatee, and dugong. The West Indian manatee is on the northern extreme of its range in Florida, where it is vulnerable to being killed by low water temperatures in winter. In the first three months of 2010, marine biologists documented 431 dead manatees in Florida, with more than half succumbing to the inordinately frigid weather that blanketed the state. Another major cause of mortality is collisions with boats, and countless manatees in Florida bear scars from boat motor propellers. There are an estimated four thousand to five thousand manatees residing in Florida, where they are listed as an endangered species, and the International Union for Conservation of Nature considers them globally imperiled.

There are numerous places in Central and South Florida where you can see West Indian manatees in the wild, including Everglades National Park, Crystal River State Park, Homosassa Springs State Park, and Manatee Springs State Park.

Manatees are herbivores and can reach 3,500 pounds, for seafarers who prefer their mermaids to be pleasantly plump.

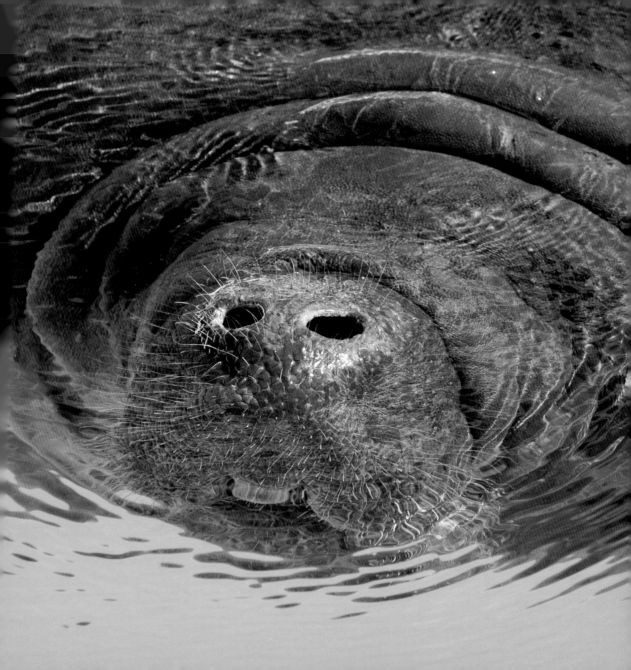

JOE'S STONE CRAB RESTAURANT

It all started in 1918, when Joe Weiss opened a small restaurant on Miami Beach. As the story goes, a fish biologist asked Joe why he didn't serve stone crab claws, and Joe responded with "Nobody would want to eat them." Now, Joe's Stone Crab is *the* place to be seen during stone crab season between October 15 and May 15 each year.

Two species of stone crabs occur along the Atlantic and Gulf Coasts of the United States but commercial harvesting is almost exclusively in Florida, with 98 percent coming from Florida's Gulf coast. It is big business, too, with more than two million pounds of claws brought to dockside in 2009 valued at more than $17 million.

Florida law forbids the taking of whole crabs, so claws at least 2 ¾-inch long are removed from the crab, and then the crab is released to grow another one. Claws may not be taken from egg-bearing

Joe's Stone Crab
11 Washington Avenue
Miami Beach, FL 33139
(305) 673-0365
www.joesstone crab.com

females. Stone crabs are harvested by the use of baited traps and are checked regularly by commercial trappers. Licensed recreational crabbers are allowed to possess up to five traps and there is a daily bag limit of one gallon of claws per person, or two gallons per vessel, whichever is less.

The sweet-tasting claw meat is a delicacy by itself, and dipping it in garlic butter is consummately sublime. But don't mention that to your cardiologist because the meat contains forty-five milligrams of cholesterol per four ounces, even without the butter.

To treat yourself to crab claws at Joe's on a weekend evening, you'll need reservations made well in advance. It may seem a bit pricey, but it's less about dining on scrumptious crab claws than it is about being seen sitting next to local celebrities like Don Shula, Gloria Estefan, Hulk Hogan, Dave Barry, or Jennifer Lopez.

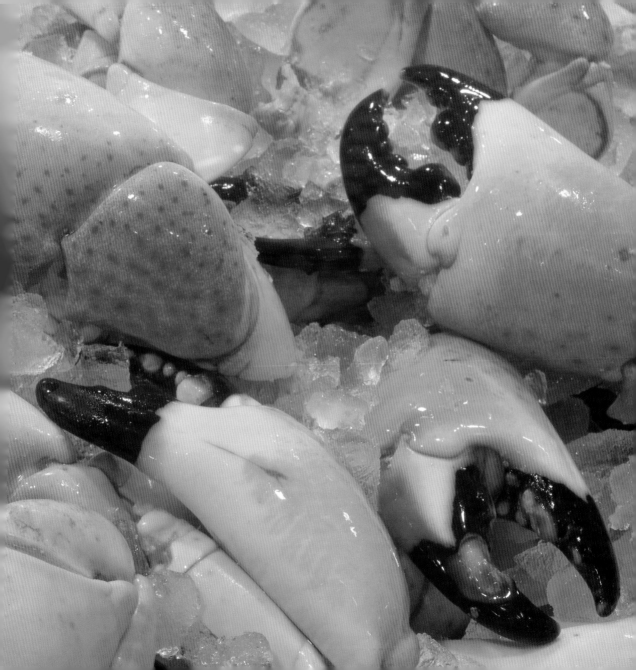

CORAL CASTLE

The girl of his dreams, Agnes Scuffs, dumped poor ol' Ed the night before their wedding. Despondent, Ed Leedskalnin, a Latvian with only a fourth-grade education, immigrated to North America, only to find hard work at lumber camps. Tuberculosis forced him to move to a warmer climate, so he came to Florida around 1919 and eventually found his way to Florida City. It was there where he sculpted over a thousand tons of the local bedrock, oolitic limestone—not really coral—into what is today called Coral Castle, and he built it alone, at night. Nobody knows just how Ed did it, but without the aid of heavy machinery, he managed to sculpt solid limestone doors, weighing tons, that open with the push of a hand.

In the 1930s Ed decided to move to a ten-acre site near Homestead on present-day South Dixie Highway, so he

Coral Castle Museum
28655 South Dixie Highway
Homestead, FL 33033
(305) 248-6345
www.coralcastle .com

singlehandedly relocated everything and eventually opened it to the public with an admission of ten cents. In December 1951 he left a note on the gate that read, "Going to the hospital." Three days later he died of cancer at the age of sixty-four. Coral Castle is still open to the public, and banners along US Highway 1 advertise the attraction with a picture of Ed and the simple message, "Who's Ed?"

Floridians might enjoy the on-location filming of 1960 Florida in the hilariously tacky movie, *Nude on the Moon,* directed by Doris Wishman. A handsome astronaut inherits $3 million and decides to build a rocket to take him and a professor to the moon. When they land on the moon (really Coral Castle), they discover a colony of topless women. The movie has few redeeming qualities, but it was extremely racy for the 1960s and packed theaters for months. Too bad Ed wasn't around to see it.

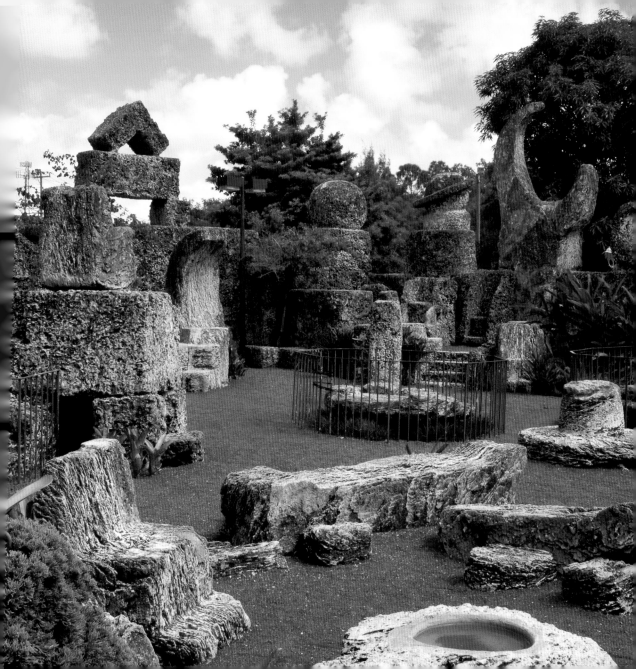

BISCAYNE NATIONAL PARK

Biscayne National Park spans 181,500 acres and, because 95 percent of it is submerged, the quiet underwater world of the park is in stark contrast to the hustle, bustle, glitz, and glamour of Greater Miami that looms on the horizon to the north. Except for the park headquarters at Convoy Point, the land-based portions of the park consist of rocky islands of the northern Florida Keys, once called *Cabezas de los Mártires,* or Heads of the Martyrs, by Spanish explorer Juan Ponce de León because they looked tortured. Offshore are fabulous reefs where divers can discover a kaleidoscope of tropical fish over a wondrous assortment of corals that make up beautiful living reefs. Although captivating to see, these reefs were treacherous for early seafarers, many of whom paid the ultimate price with their lives when they miscalculated their navigation. Remnants of sunken ships litter the bottom, and some still with their cargo of gold doubloons.

Biscayne National Park
Convoy Point Headquarters
9700 SW 328th Street
Homestead, FL 33033
(305) 230-7275
www.nps.gov/bisc

Biscayne National Underwater Park, Inc.
Boat Tours
(305) 230-1100

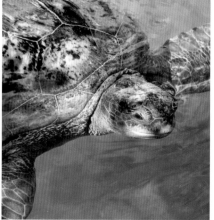

Within the park there is a sixty-five-foot-tall historic lighthouse that towers above Boca Chita Key, the most popular land-based site for visitors. Mark Honeywell, who once owned the island, built the lighthouse, but the Coast Guard would not authorize him to light it. There is also a small group of rustic wood houses built on pilings above Biscayne Bay between Boca Chita and Key Biscayne, affectionately called Stiltsville. The first ones were built in the 1930s because gambling was legal one mile offshore.

Glass-bottom boats and dive boats leave daily from the park headquarters at Convoy Point, and tent camping is available on Elliott Key and Boca Chita Key for visitors who wish to stay awhile. For those who might enjoy debauchery at sea there is the Columbus Day Sailing Regatta, which has morphed from a sailing race into an event more closely resembling a Mardi Gras at sea.

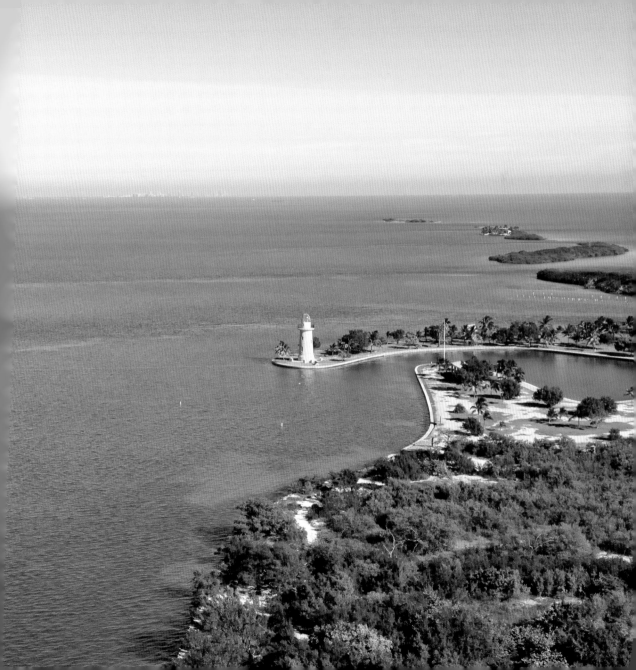

GREEK SPONGERS OF TARPON SPRINGS

In their heyday prior to World War II, Greek spongers living in Tarpon Springs were harvesting upwards of six hundred thousand pounds of sponges a year and had a fleet of two hundred vessels. Today there are only a half dozen boats that bring in about sixty thousand pounds of sponges annually.

The story of the Greek spongers actually begins in Key West. A market for sponges was created after some enterprising Keys residents began harvesting sponges from boats with long-tined rakes. Some samples were sent to New York, and the demand for them was overwhelming. Boats filled to the brim with sponges began sailing from Key West to Tampa Bay where they were taken by wagon to New York.

In 1889 a wealthy Philadelphia banker named John K. Cheney realized the value of sponges off of Tampa and began building warehouses at what is now Tarpon Springs to supply the

City of Tarpon Springs
www.ctsfl.us

insatiable New York market. In 1896 John Cocoris, a Greek sponge buyer from New York, showed up in Tarpon Springs and began bringing sponge divers from Greece to increase the take. By 1906 there were 1,500 divers from the Aegean Sea working the Florida fleets. These divers wore suits with heavy helmets attached to long ship-to-diver air hoses. Sponges were cut off at the base so they could regenerate, packed into bags, and then hauled up to the ship. It was quite profitable, and for thirty years sponges outpaced tourism and citrus as Florida's most lucrative industry. The industry eventually collapsed due to diseases that killed the sponges, devastating red tides, and the invention of artificial sponge. But a little bit of tradition still hangs on in Tarpon Springs, and with all those Greeks living there, you will find some of the best Greek restaurants anywhere in Florida. The baklava is resplendently decadent.

CAPE CANAVERAL

"Fly me to the moon,
Let me play among the stars,
Let me see what spring is like,
On Jupiter and Mars."
—(Bart Howard, 1954)

Kennedy Space
Center Visitor
Complex
(321) 449-4444
www.kennedy
spacecenter.com
/Florida

Kennedy Space
Center
(321) 867-5000
www.nasa.gov
/centers/kennedy

The first manned flight to Earth's moon was launched from Cape Canaveral in Brevard County, Florida on Wednesday, July 16, 1969, with American astronauts Neil Armstrong, Michael Collins, and Edwin "Buzz" Aldrin, Jr. aboard Apollo 11. On Monday, July 21, Armstrong stepped off the footpad of the landing craft named *Eagle* and announced back to the planet Earth, "That's one small step for man, one giant leap for mankind." Aldrin described the view as "magnificent desolation."

The name "Cape Canaveral" comes from the Spanish *Cabo Cañaveral* and can be attributed to the 1521 voyage of Spanish explorer Francisco Gordillo. The Cape was chosen as a missile launch site by NASA because the ocean provided an

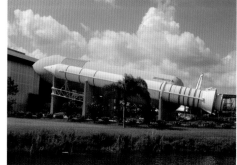

area away from populated cities in case of a mishap (and there have been many) and because missiles could be sent aloft heading eastward to take advantage of Earth's rotation. It was renamed Cape Kennedy in 1963 after the assassination of President John F. Kennedy, but changed back to Cape Canaveral ten years later.

The very first rocket launch from the Cape was called the Bumper 8 on July 14, 1950, and the first intercontinental ballistic missile, the Titan, soared skyward on February 6, 1959. Nearby Port Canaveral harbors an important U.S. Navy dock for submarines armed with Polaris and Poseidon surface-to-surface missiles, and is also one of the world's busiest cruise ship ports.

Tours of the Kennedy Space Center Visitor Complex are available to the public, where missiles and space shuttles can be viewed up close. Tours of the Kennedy Space Center are also available, where you can enjoy lunch with a real live astronaut.

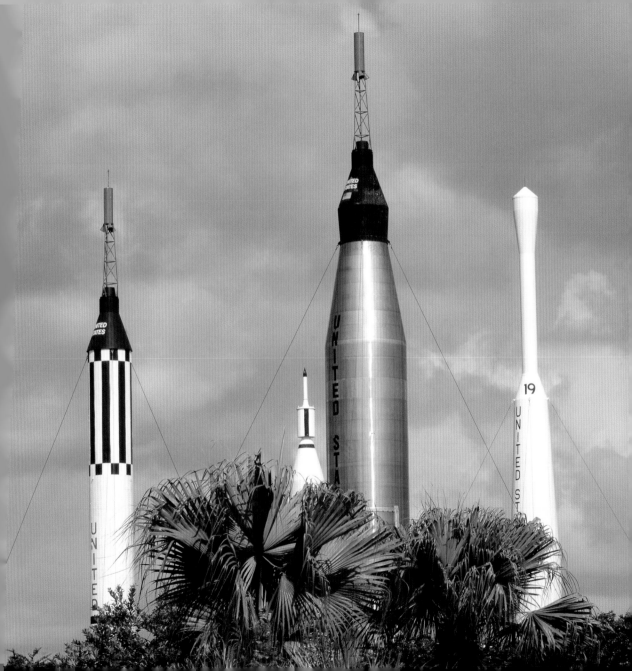

PINK PLASTIC LAWN FLAMINGOS

There is hardly anything quite as laughably tacky as a pink plastic lawn flamingo, that Florida icon that is either castigated as being in exceedingly poor taste, or revered by the Art Deco crowd as totally chic. Some cities deemed them to be so objectionable that they passed ordinances against their public display. And, because plenty of people believe lawn ornaments rank alongside velvet Elvis as the epitome of tackiness, what better way for someone to annoy their neighbors than with a flock of pink plastic flamingos displayed on their lawn?

American artist Don Featherstone developed the original plastic lawn flamingo in 1957 when pink was all the rage, so it quickly became a fad, especially in Florida. Featherstone was even awarded the Ig Nobel Art Prize (taken from the word *ignoble,* or "dishonorable") for his creation of the now-iconic, albeit chintzy, lawn ornament. The Ig Nobel Prize is a parody of the Nobel Prize and is awarded for achieve-

ments that "first make people laugh, and then make them think." Apparently a pink plastic lawn flamingo makes people ponder the meaning of life after the guffaws finally subside.

The lawn flamingo is, of course, based upon the real flamingo, another Florida icon pictured on the Florida Lottery tickets and depicted as croquet mallets in *Alice's Adventures in Wonderland.* Many attractions in Florida keep flocks of flamingos as living ornaments and these include the Hialeah Race Track, Sarasota Jungle Gardens, Silver Springs, and, of course, Flamingo Gardens.

To see real wild flamingos look for them in Florida Bay near Flamingo in Everglades National Park. This old fishing village actually got its name from the stilt homes built there before the turn of the nineteenth century, which were constructed on pilings to protect them from flooding. They likened the stilt homes to long-legged flamingos.

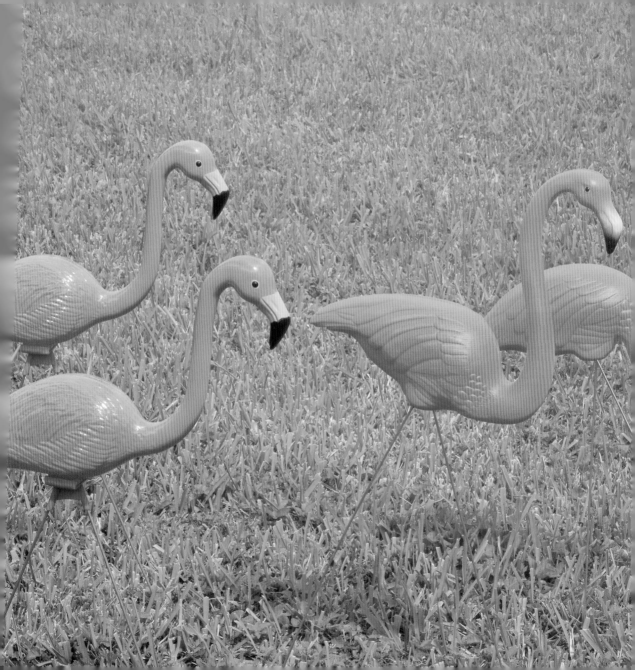

ABOUT THE AUTHOR

Roger L. Hammer is a professional interpretive naturalist. He received the first Marjory Stoneman Douglas Award presented by the Dade Chapter of the Florida Native Plant Society in 1982 for "outstanding, consistent, and constant service in the areas of education, research, promotion, and preservation of native plants." Tropical Audubon Society awarded him the prestigious Charles Brookfield Medal in 1996 for "outstanding service in the protection of our natural resources." In 2003 he received the Green Palmetto Award in Education from the Florida Native Plant Society, and in 2008 he gave the keynote address at the Nineteenth World Orchid Conference in Miami. Roger's hobbies include gardening, canoeing, camping, kayak fishing, birding, and wildflower photography. Roger is also the author of *Everglades Wildflowers* (Globe Pequot Press, 2002), *Florida Keys Wildflowers* (Globe Pequot Press, 2004), and *A FalconGuide® to Everglades National Park and the Surrounding Area* (Globe Pequot Press, 2005). He lives in Homestead, Florida, with his wife, Michelle.

PAUL MARCELLINI